ANVIL PRESS PUBLISHERS INC,
P.O. Box 3008, Main Post Office
Vancouver, B.C. V6B 3X5 CANADA

ANVIL PRESS
INDEPENDENT
PUBLISHERS
www.anvilpress.com

Library and Archives Canada Cataloguing in Publication

 Damp : Contemporary Vancouver Media Arts / Oliver Hockenhull, Alex MacKenzie, editors.

ISBN 978-1-895636-89-5

 1. Arts--British Columbia--Vancouver. I. Hockenhull, Oliver II. MacKenzie, Alex

N6547.V3D35 2008 700'.971133 C2008-900213-X

Printed and Bound in Canada
Cover & Interior Design: Alex MacKenzie & Oliver Hockenhull

Represented in Canada by the Literary Press Group
Distributed by the University of Toronto Press

The publisher and editors gratefully acknowledges the financial assistance of the Canada Council for the Arts, the Book Publishing Industry Development Program (BPIDP), and the Province of British Columbia through the B.C. Arts Council and the Book Publishing Tax Credit.

For their support, encouragement and input, the editors wish to thank Alternator Gallery for Contemporary Art, Brian Kaufman/Anvil Press, Cineworks Independent Filmmakers Society, Charles Street Video, Images Festival, Khyber Centre for the Arts, Lux (London), Pacific Cinematheque, Pleasuredome, Plug In Institue of Contemporary Art, Saw Video, Starting From Scratch Festival, VIVO Media Arts, Western Front, and all of the contributors.

DAMP

CONTEMPORARY VANCOUVER MEDIA ART

EDITED AND DESIGNED BY OLIVER HOCKENHULL AND ALEX MACKENZIE

4

The primary intent,

that which whetted our appetite for this project, was the thought of creating a unique and disparate cry of the quick, an original yelp from a particular site of transit, a locale both mythic, undisclosed, and yet wholly of a destination.

Vancouver.

The terminal and a once extremity; the set sun of a dead Empire and the ending South West slope of a Northern colony, a place where the shaken loose nuts and bolts will roll to.

A once upon a time and now.

Is there a sense that by reaching the end we can clean our slate, erase history, and come up with something wholly unique and unspoiled? Is this attitude only an immaturity, a utopian imaginary, or the only fortune worthy of this place?

Both a blessing and a curse, Vancouver's remoteness from the rest of Canada and its relationship of grave imbalance with its US neighbour leave it to invent itself.

Vancouver remains an outpost and a city so conditioned by signs of nature and of the primal that its identity begs a question that may best be answered through the myths of its original inhabitants and its new immigrants. This too is reflected in our media artists and media landscape, and here as well, most poignantly, history and politics are recalled. History is a by-product of latency, a predictive so vast that it encompasses the lost souls, the hungry ghosts, the newborn, both the poorest and wealthiest postal codes in the country,

the throngs with a long-term mortgage concern and those, so many, in perpetual limbo.

DAMP as a flirt with a never coming tomorrow, a utopian and modernistic impulse now corrupted, polluted, sold out, and abandoned—a strategy of an untoward movement, of a time-based papillon pinned to the frames of uninhibited vision, the unexampled of an exhausted West renewed and reinvigorated.

Oceanic and simultaneously marginal, exacting, ecological, dissolving and restoring in a program of various blinding and contradictory lights.

Simply put, not the easy approachable or the purchased for a price.

The end of the West as a radical living and thinking in terms of place—place being the signature of the uncompromising—rather than living in terms of the dictates of international capitalism and the authority of followers.

Between a hard place and drowning, tumbled down from Wagnerian peaks, feet exalted in salt water. Truth as the ease of the forgetting sky raining history.

So we are here, it is normal, usual, precipitous and splendid.

What can be done?

Embracing a particular aberration, a niche in the seamless, a widening of the diacritic.

We as editors sought to focus content on the present and future of the media arts, but some space is necessarily

and engagingly devoted to the utopian aspirations of the founding organizations and artists of Vancouver media arts. This classic return of the repressed is not sublimated in terms of antagonism towards 'mericans, 'the industry', the state of 'Canadian film', or that particular cinema that once was thought to be needed, but more a singular step to a furthering—here in the land of lotus eaters.

By re-focusing on hidden and suppressed histories, the city's internal and external mythologies and imaginary futures, we reveal a largely unambiguous and unacknowledged praxis. And by melding theoretical and writerly concerns with visual and graphical allusions we can walk the talk of material production.

Vancouver is in a ceaseless process of decomposition and recompositing, a factor of its environment—climatic, geographic, economic, and social. And so this book: a necessarily incomplete cultural inventory and analysis of the moving image—its current practice in Vancouver and a revealing of those media makers working as riptides in a sea of submission.

Oliver Hockenhull & Alex MacKenzie,
Editors/Designers

In Order Of Appearance

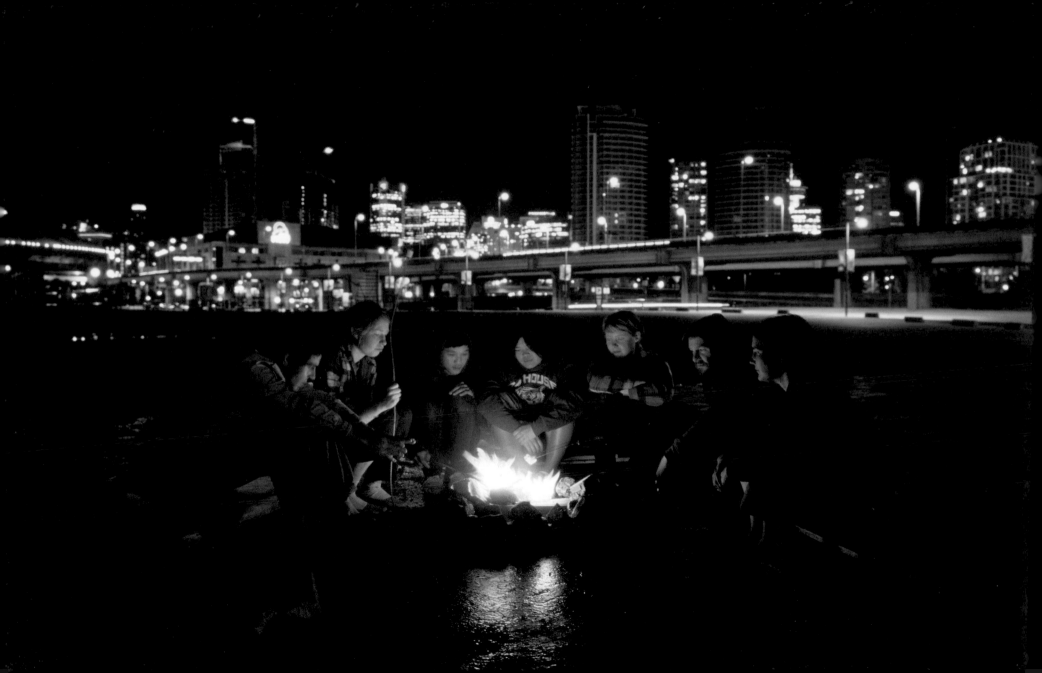

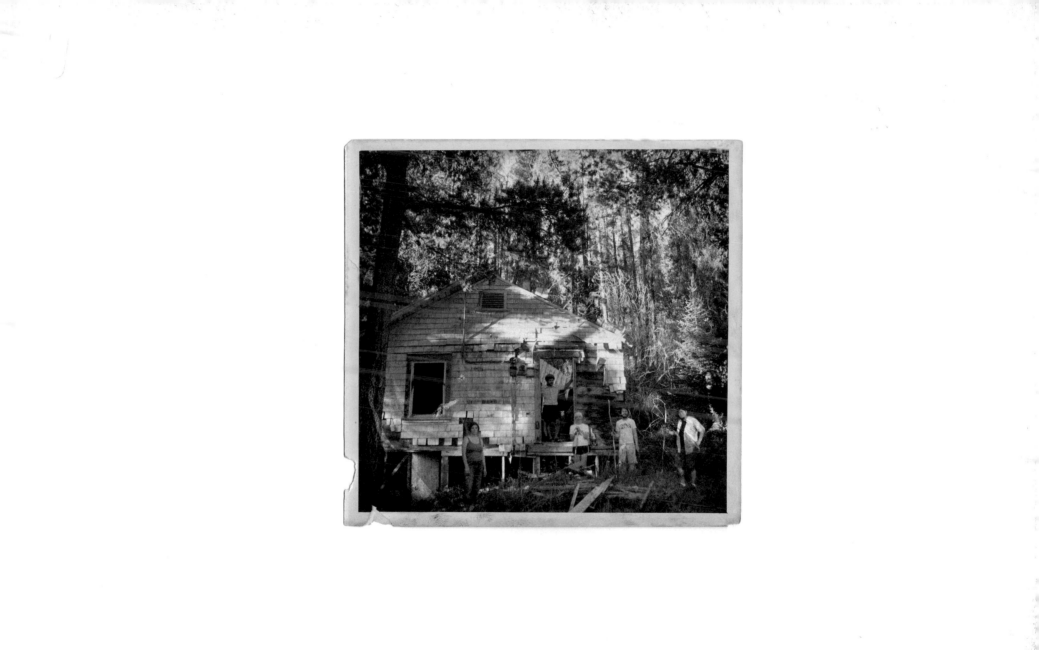

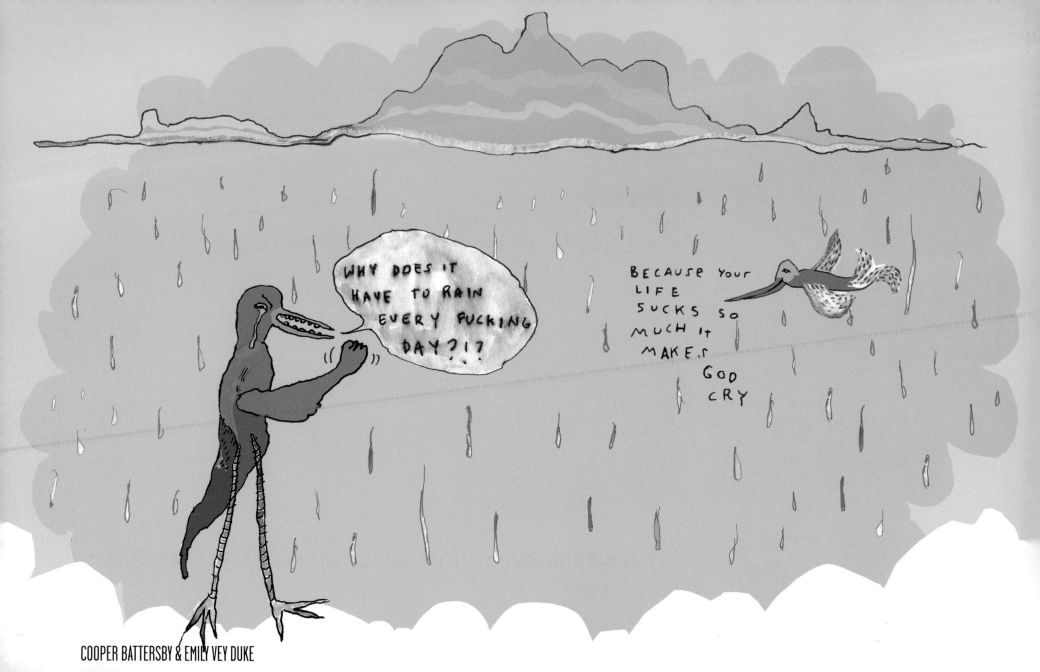

COOPER BATTERSBY & EMILY VEY DUKE

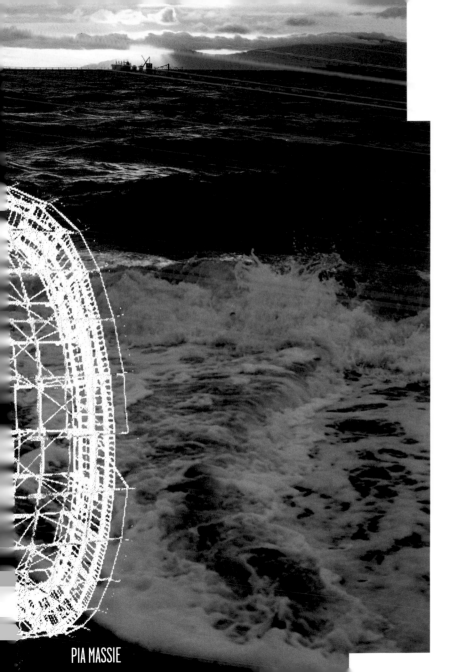

PIA MASSIE

Where east
hastings & renfrew meet

The smell of glazed popcorn and cotton candy, the snap of oil heating up the summer air, the shrieks of teenagers barely distinguishable from the tantrums of overheated toddlers and the sighs of frazzled mothers—a slew of noise rising up over and over, a shimmering veil of heat rippling and breaking on the frozen past. This garish amusement park is just a thin distraction, a flimsy curtain pulled over time—a long winter still within memory, when discrimination and greed slicked the ice for land grabs and eradication of a group of people—again.

I wish I had been there the day the city burnt the stables down: a scorching fire, a thorough destruction of the shameful evidence, a clearing of the ground for Vancouver's Playland. I try to get my aunt to talk about internment but she is silent. All I could capture were images of her in her old house where she lived off the grid (still so terrified of the government) before she was moved to a care facility. She is always trying to move out of the frame.

They barely made it through that time—sleeping on straw, the big wooden slats of the pens surrounded by wire fences. There was snow. They had nothing but each other and even the families scattered—got smashed: children and grandmothers locked in the police horse stables, brothers and fathers taken away, separated.

Where women once ate grass and scraps flung through the fence from ashamed passersby—on this same block of land where my ancestors were called traitors for our faces—now we can ride the Ferris wheel in the heat of summer and oblivion.

My cousin hustles me off to the bus station early. She is furious that I tried to film my aunt. "Can't you see how uncomfortable you make people?" she asks. My aunt's silence is the voice-over that by saying nothing, says it all. How many generations of fear will be passed down?

I want you to know this place for what it is and what it was: for the obscene gap between the past and the present, your people and mine. Imagine—your possessions will be stolen, ransacked or destroyed in rage—perhaps your own at having to leave them behind. What would you take with you to hold on to your sanity if you could pack only two suitcases? And what would you leave behind? Nothing and nowhere will ever be safe again.

NW **corner**
broadway & cambie **street**

Woke myself up from a nightmare. A long bare elegant arm was putting on my mother's watch, fastening the troublesome little clasp with nimble perfect fingers. With a shock I realized it was lost to me. I wanted to cry, or I think I was crying, but actually I was more scared than anything.

What had I lost? How had I lost it? **And why?**

I had lost track of time—years, and now decades, were going up in little puffs of smoke. I had lost my mother. Yes, this happened long ago but now I was losing her memory too. I had let go of my drive; lost the will to perfection of that beautiful arm with its effortless know-it-all fingers.

But why be scared to lose these—aren't they things that can never be lost—just sucked further and further back in to the bone? The watch had been in a safety deposit box in another part of town. That was strange, and true too.

A guy I barely knew, a friend of a friend who is no longer a friend, had pressed me to put my mother's "things" in the bank, in a "secure" safety deposit box. Then I was asked to leave the country. Then he died of AIDS or complications leading to it. Then the person who connected us decided to break our friendship.

Recently, when I was back in that neighbourhood I saw that the solid granite building of the bank had vanished. What was left was a huge pit. Signs saying "Crossroads" surrounded the excavation. **Future condos.**

The core of my work is always loss. I wish it were joy instead. How to capture something so ethereal? So gone? That thin little watch, extremely hard to read, quite valuable and very old fashioned is sharply in focus.

Who has it now?

NE corner Cornwall Avenue & Arbutus Street

The day I saw a tank barring the street I no longer wanted to live in New York. A black woman was sobbing, held back by policemen as she tried to get onto the Brooklyn Bridge. "I've got to go find my son," she screamed. 9/11 made it crystal clear to me that I couldn't raise my child there, where I had grown up. When he was not yet two, he asked, "How could there be a war in a rock?"

I used to be ready to leave at a moment's notice. I was the one who could pack swiftly, effortlessly, and completely—leaving no trace behind. In twenty years I lived in twenty places, in five different countries. Crossing borders was a game I was born to play.

I gave it up finally. I quit.

Now Kits Beach is my home. I am settling in slowly, unpacking only bit by bit. For the first few years here, I took photographs relentlessly:

sky, water, mountains, sand, and clouds

—a meeting of determined equals. It is a different spot every split second; each frame capturing only a moment of weather on the cusp of becoming. It is the end of a country; the far left edge of the West before the corridor of the Pacific Ocean and the East begin.

For myself, schooled and raised in displacement, the work is a method of asking: Whose memory? Where's home? What country? How does "when" relate to "now"? And always, Why? In **More Home Some,** an itinerant movie I made twenty years ago, no two people define home the same way. In contrast, **Sayonara Super 8**, made last year here in Vancouver, looks at the end of an era of innocence, of home movie-making, of the lovely tactile medium of the film itself. It is still searching, but for details and connections, not proofs.

Maybe tiny fragments of memory are all that I can offer you to stay afloat—the smell of rice cooking in the kitchen my mother never saw again, the clear small sound of the bell in the garden swaying in the breeze, a glimpse of my father's sombre accepting face as he exits the door frame, a belief of time that is serene and graceful—able to lay down afternoons of dappled light, simple and full of delicious stillness.

Like Hokusai's *Hundred Views of Mount Fuji* I continue to study this piece of land for clues as to how to connect the past and the future, as if the math of form, temperature, and humidity pressed to the page could divulge the gorgeous paradox of an occupied territory.

A Typical Vancouverite

Ileana Pietrobruno

I ate an ice cream sandwich recently. It tasted exactly the same as I remember. When I was a kid, I spent every single day of summer at Second Beach, and every day, I used my dime to buy an ice-cream sandwich. That was the best part of the day.

I write in my room.

In Vancouver.

Does it matter where I am? I could be anywhere. I know nothing about nature. I don't do camping and stuff. The only nature I saw growing up was the combed beach with the logs in a line and the hot dog stand that sold ice-cream sandwiches.

Broadcasters and funders say that they're looking for the West Coast identity. In actual fact, they've already decided what it has to be. You know...canoes, trees, beer, Mack jackets, moose, totem poles, salmon, Native stories told by non-Natives, and family dramas about alienated, Anglo fathers and sons who go fishing. It's all these empty clichés and tacky kitsch and that's what people want repeated over and over again. I don't feel a connection or a feeling of home when I see those images or stories. I get depressed.

I'm a West Coaster, for sure, and yet I have none of this romanticism for nature. Maybe it's those people that have moved here as adults that have it. When we first came to Vancouver, my parents drove somewhere and I remember sitting on a hill and my mother got devoured by flies and mosquitoes and she was miserable! Fed up! So we all packed ourselves back into the car and that was it; we never ventured into the country again. Growing up, my natural environment was the West End, which I thought was great and my parents were like, "You

couldn't ask for more nature than this." I mean, Stanley Park is huge, huge, huge. Not that my sisters and I could ever go *into* the park 'cause you'd get raped. We'd go around it on our bicycles.

In my room, I wrote a film called *Girl King* about drag king pirates. Drag king pirates are not going to be considered suitable content for a West Coast film. Why not? I don't know. The West End where I grew up was gay from the moment I was here. I don't know how long it was gay before then. I lived with my parents above the restaurant that they owned and operated, and all the waiters were gay. I was surrounded by drag queens and our favourite thing to do as children was to watch them play baseball on Sundays, at the entrance to Second Beach. It was gay baseball, but there were certainly a lot of shrieking drag queens. My mother's only friend was the first male to female transsexual in Vancouver. When I was a child, she was perceived as a man with a masculine name. I remember one time she used my parents' restaurant to host her own party, a long evening-gown type of affair. Of course she arrived in a mini skirt. Drag was never strange to me. That's why it was so normal for me to become an adult and to make a drag king film like *Girl King*. It was...obvious.

Why did I make a pirate film? Well, I used the image of the pirate as a metaphor for the drag king's crossing and transgression of borders and boundaries. But I mean, basically, here I am in this coastal province, British Columbia, that's been plundered, pillaged, and exoticized by European Imperialism so, again, it was obvious to me that I should make a pirate film. When a Czech reviewer saw *Girl King*, he said, "I had no idea that Vancouver is so exotic." He meant the parrots and monkeys. They exist in *Girl King* as heavily pixilated images, loudly

12

announcing themselves as stolen (although the Czech reviewer missed that). This tropicalized landscape calls attention to its own artificiality and suggests that nature does not naturally exist, as is, outside of representation, cultural codes, or language. There's nothing authentic or natural about the nature in *Girl King*. It is a pirated landscape, inhabited by drag kings who have pirated masculinity. We have been taught to believe that "male" and "female" are natural dichotomies, but as Rupaul says, "You're born naked and the rest is drag." Drag kings know that masculinity is not biological; it is a social construction. It is a piece of clothing, a stance, an attitude. Drag kings denaturalize gender which tries to pass itself off as effortless and natural. For centuries Western thought has equated Nature with Woman, but actually Nature is a Drag King.

Technically, I can't say that I grew up in the West End because we were actually in the industrial area that bordered the West End. In a sense, my family was 'in hiding.' My parents were very isolated people, without any family or friends, and ironically they orchestrated a life that continued to be very isolated from any community. Surviving the war and the holocaust had made them somewhat paranoid. They didn't want us telling people anything about anything. To this day, my closest friends know nothing about my childhood or my background. Many people still think that I come from a large Italian family.

This claustrophobic tone that I grew up in is all over *Cat Swallows Parakeet And Speaks!* It's a film about death and decay which probably stems from watching my mother die. At the age of thirteen I learned that we die, that I die, and this knowledge gave me a tremendous amount of strength because it made me realize that my life is very valuable. I didn't take it for granted and I decided that in life I am going to do what I want to do. This idea that in life we are always dying—and that that's a good thing—is what makes *Cat Swallows Parakeet And Speaks!* perverse.

All the characters in *Cat Swallows Parakeet And Speaks!* are struggling to be healthy, beautiful, young, and happy, and then they realize that amorphous fluidity, or states of transformation, are actually where the life is. The film depicts a modern Snow White who has been embalmed so that she is always young and beautiful, but what she dreams and longs for is to rot and decompose because it's through this decay that she will become alive. The bodies in *Cat Swallows Parakeet And Speaks!* are always seeping past boundaries and refusing to be made static or controlled by medicine, science, and logic. They are too fat and they menstruate too much. They're like the nature that overruns the hospital with vines, birds, mice, insects, worms, dirt, and soil. There's so much soil that the two main characters are buried by it, and even the celluloid film itself disintegrates. For me, *Cat Swallows Parakeet And Speaks!* is a celebration of entropy, death, decay, and illness.

Right now, I'm making a film about prostitution. Now that's part of the Vancouver landscape! Did you know that we have the longest stroll or track in the world? It's called Kingsway. I've always seen Vancouver as a port town with a history of prostitution. And again, I grew up off of Davie Street, off of Richards Street, and off of Georgia Street. Prostitution has been in my realm. My father was always visiting prostitutes. He spent his life trying to get as far away from Europe as possible (which is why he moved to the West Coast of Canada rather than the East Coast), but he was still a very European man with that accompanying European sensibility around prostitution. When I was a child, he told me all about the

Parisian hookers who went on strike when the city tried to tax them. He was so proud of them for beating the system. Unfortunately, the prostitution scene in Vancouver isn't much like his stories.

Growing up in a restaurant is like growing up in a theatre. There are always lots of unusual characters coming and going. That may be part of the reason why, imaginatively, I've never been silenced. If I have a weird, strange image in my mind, I'm not going to shut it down. I'm not afraid of weird things 'cause I don't think they're weird. I've never made anything with the intention of trying to fit in, but in spite of this, my films do belong within a larger socio-cultural conversation, like for instance, the current discourse on female representation and queer identity.

Vancouver is such a money-oriented town with such a utilitarian attitude towards the arts that it's often difficult to find one's self-worth as an independent filmmaker. But I do know that my world exists far beyond the provincialism of Vancouver. When I was writing *Girl King*, I stumbled on a thick catalogue for a show at the Guggenheim Museum in New York entitled "Gender Performance In Photography." That was inspiring because although it often feels like I'm working inside my own head of weird ideas, I'm not—I'm working alongside everyone else's weird ideas.

What's important to me when I'm making a film is how the setting, the action, and the ideas all connect. On my shoots, the actors often have a horrible time because they feel as if they are less significant than the set, and it's true that I tend to write flat characters, not simply because they really don't matter that much, but also because I don't psychologize them

by turning my own life stories into theirs. I have no interest in relating the little incident that happened to me, and then the other little incident. There is absolutely nothing autobiographical in my films. I don't tell family stories (because my parents would rise from their graves in anger!). I don't make personal films.

But in the process of this writing, I've discovered that my films are offshoots of my childhood, and that my ideas are, in fact, very nestled in this place.

I grew up around drag queens, and then I made a film about trans-people, drag kings, and differently gendered people.

I grew up in a dysfunctional, immigrant family that lived on the outskirts, and now I make insular films that are fueled by my idiosyncratic imagination, and I'm still living in more or less the same way that my parents did—on the outskirts, the fringe.

So, as it turns out, I have been very influenced by this environment. It's just that it's not an environment that people think of as typically Vancouver.

But in actual fact, it is.

And so are my films.

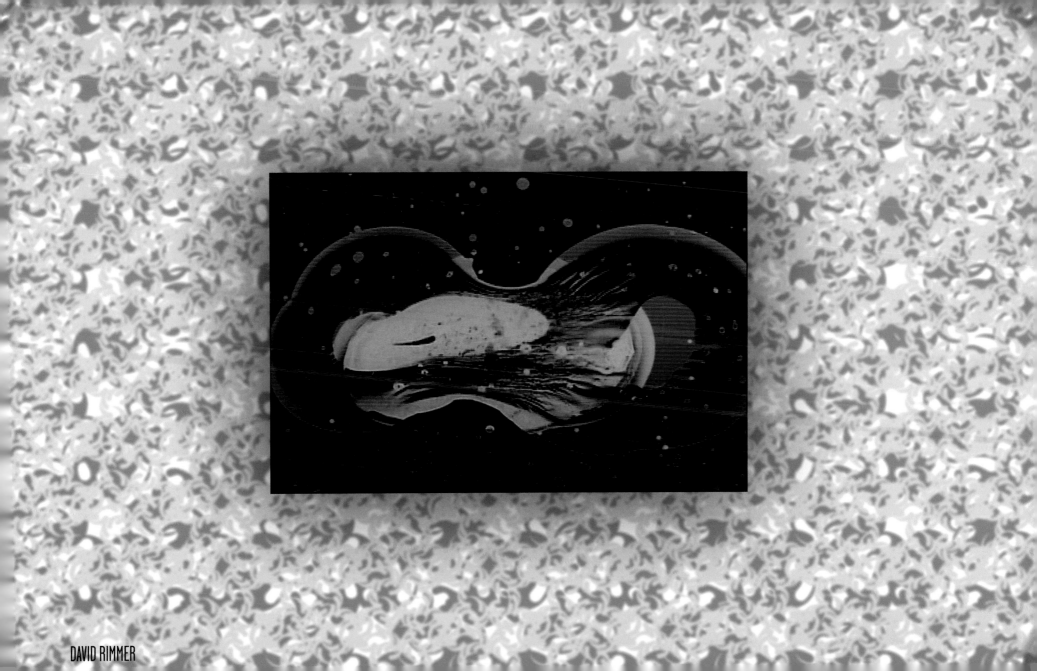

DAVID RIMMER

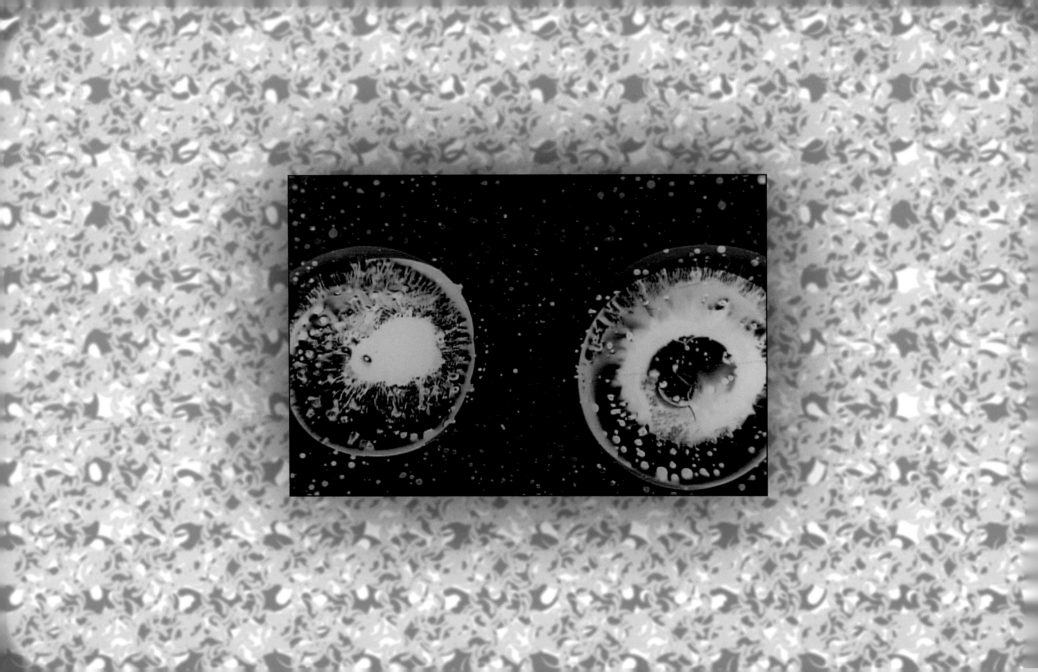

HAUNTED BY THE LIGHT

These ideas of paranormal and birth of communication technologies have survived as metaphors of a willful irrationality, unreason and a desire to see beyond the instrumental ubiquity of contemporary technology.

Jeffrey Sconce, Haunted Media: Electronic Presence from Telegraphy to Television, 2000

a field guide to eLectronic presence in vancouver

electronic presence

Electronic presence, a force that occupies our external and internal worlds, has at least two distinct meanings. The first refers to the ubiquity of digital media in our daily lives: cell phones, the Internet, satellite radio, and the like. More oblique is the second, which calls up the origins of electricity in the nineteenth century and the invention of the telegraph at the turn of the last century and with each, an attendant fascination with ghosts, phantasms, and spirits. In the overlapping cultures of communication technologies and the paranormal, there is an echoing of effects: here boundaries of space and time are broached, interwoven, and folded into each other. The results are a range of arresting phenomena that shine a spotlight on the spectres and manufactured illusions of media culture, not to mention our own projections and desires. Whether considering twenty-first century devices and their expanded networks, or nineteenth century energy production and distribution, electronic presence haunts the fields and fibres of being.

RANDY LEE CUTLER

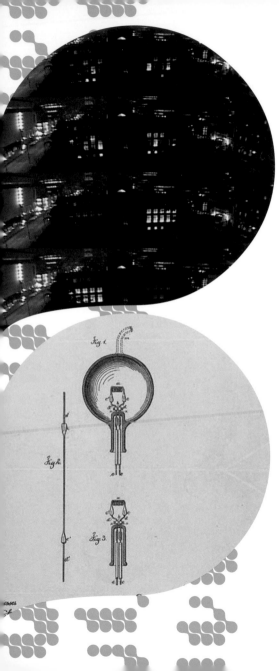

doppelgänger

One way to consider electronic presence is through the German word doppelgänger, usually defined as a ghostly double of a living person. It is derived from doppel, meaning "double," and gänger, which loosely translates as "walker." While it suggests any double or look-alike, doublewalker as a term evokes the advancing presence of electronic culture, a phenomenon where the inanimate, namely technology, either appears sentient or engenders parallel worlds. According to media theorist Sconce, contemporary discourse offers some explanation for the endless play of meaning and unmeaning in our cultural networks. "In pomo's fascination with the evacuation of the referent and an ungrounded play of signification and surface, we can see another vision of beings who, like ghosts and psychotics, are no longer anchored in reality but instead wander through a hallucinatory world of eternal stimulation where the material real is forever lost." Here we find doubles, clones and simulacra via electrical transmission; shape-shifting doublewalkers and phantasms of the living in expanded form. Whether television, cinema, mobile devices, or experimental art, digital media often highlight spectral effects. In Vancouver, the overlapping fields of art, entertainment, and FX technology continue to showcase futuristic and dystopian visions: the phenomena and noumena of a schizophrenic culture. Electronic presence, a shadowy double of lived experience represents contemporary haunted media, strange yet familiar.

light bulb

By 1875, Edison contributed to the success of the light bulb when he invented a carbon filament that burned for forty hours. Near the end of his life, in 1920, he announced a project that created an unusual application for electronic communication. "I am building an apparatus to see if it is possible for personalities which have left this earth to communicate with us." Perhaps paranormal happenings and invisible lines of communication were the real or covert inspiration behind industrial applications for electrical current.

In folklore, the doppelgänger reveals itself by casting no shadow. A play on this was found in Hadley+Maxwell's exhibition Deleted Scenes at the Contemporary Art Gallery (March 31 — May 28, 2006). In their installation ...Um, traces of electronic presence seduce the viewer through a doubling and slowing down of time, creating an uncanny space for deliberation. The work, located in a discrete corner of the gallery, contained a video projector, the footage of a swinging light bulb, a light bulb illuminated by the moving images, and a cast shadow of the latter onto the video image. The loop consisted of 5 "experiments" or sequences involving the sculptural and video components. In one of them the light bulb swung like a timepiece, and flashed on and off. As the video projected through the light bulb and onto the wall, a phantom light seemed to emit from the three-dimensional object. The flickering was reminiscent of the binary language of zeros and ones, a Morse code communiqué or more menacing perhaps, correspondence from "the

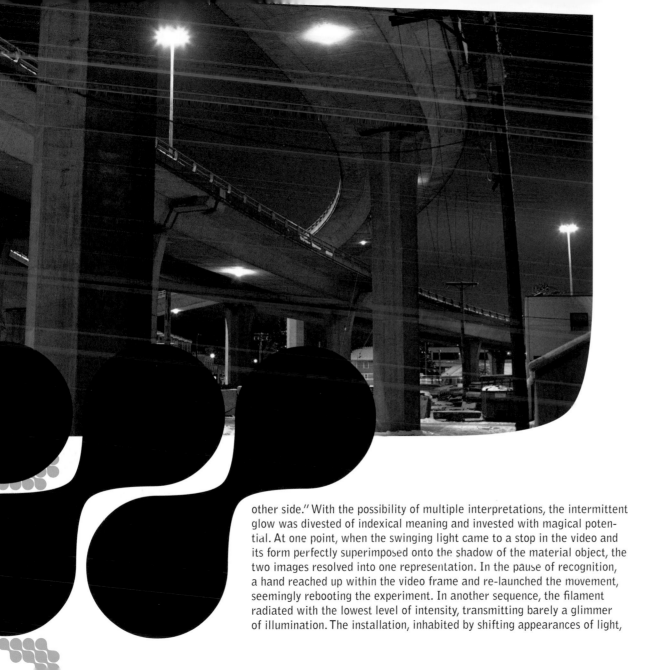

created a circuit of information that passed between the projection, the object, its shadow and the image. With its queer flickering light, ...Um summoned up a history linked to ideas of representation, the paranormal and electronic telegraphy.

According to Marshall McLuhan the light bulb is a demonstration of his theory that a medium affects society not so much by the content it delivers but by the medium itself. The light bulb creates light, space, experience, and environments that enable people to communicate in radical and pervasive ways. Perchance it carries the animating "spark" of consciousness itself. Like our current fascination with digital media, the light bulb is a ubiquitous communication medium that blurs the boundaries of space and time. It's meaning doubles and expands from a source of light and an electronic presence to a symbol for animated life forms, inspiration, and energy.

network branding

Branding, specifically network branding, a case study of the double-walker effect, has been infiltrating our televisual field for more than half a century. In recent years, these symbols or "service marks" have morphed into sophisticated mini apparitions that suddenly appear on the edges of your television screen like a thick vapour resolving themselves into the static corporate logos of CTV, Global, the Knowledge Network, A channel, etc. The swirling forms seem to emerge out of the ether, settling into a corner of the image and lingering until the commercial sponsor takes control of the airwaves to replace the transparent trademark with its own consumer heraldry. Even more spectral are the graphic abstractions of the human eye found in the American CBS and Canadian CBC emblems. The designer of the American version, William Golden, was originally inspired by a drive through the Pennsylvania Dutch countryside, "where he became intrigued by the hex symbols resembling the human eye drawn on Shaker barns to ward off evil spirits." Rather than protect you from

other side." With the possibility of multiple interpretations, the intermittent glow was divested of indexical meaning and invested with magical potential. At one point, when the swinging light came to a stop in the video and its form perfectly superimposed onto the shadow of the material object, the two images resolved into one representation. In the pause of recognition, a hand reached up within the video frame and re-launched the movement, seemingly rebooting the experiment. In another sequence, the filament radiated with the lowest level of intensity, transmitting barely a glimmer of illumination. The installation, inhabited by shifting appearances of light,

the unknown, the monocular form on your television set seems to stare back. With the ubiquity of communication technologies, the seemingly infinite number of television channels, and the expansion of digital media, it is unclear who is staring at whom, who is animate and who is inert. A Canadian example with its graphic elaboration on the letter "C" is the CBC logo, which also evokes a pupil at the centre of a dilating sphere or a camera shutter vibrating open and closed. As a child watching Saturday morning cartoons, I imagined it as a reflection of my own eye anatomy or, more sinister perhaps, a phantom scanner watching me as my parents enjoyed their weekend sleep-in.

digital on-screen graphics

Digital on-screen graphics, "DOGs" in the UK and "bugs" in North America, are a relatively recent phenomenon. They first landed on the television screen surface in 1994 during an ABC NASCAR broadcast. According to Wikipedia's entry for Digital on-screen graphics, "A transparent digit counted down the number of laps remaining in the race." Similar bugs quickly followed, usually broadcasting the score for a sporting event. More than a decade later we find ourselves swarmed by a nether world of network branding and identification; a world where no screen is left debugged. Like the endless availability of download able ring tones, these screen logos signify a multi-signal

universe where surfing through hundreds of channels has become a norm. Ostensibly, they tell us where we are. But more than just visual noise in an already crowded media environment, our perceptual fields are infested with "Bugs, DOGs, Logos, Idents, Emblems, Brandings, Trade Marks, Red Dots, Promotions, URLs, Gimmicks and other Screenjunk." Permanent visual identification of the video signal has made contact: ghoulish branding has come of age leaving its spectral traces on our optical nerves and nascent desires.

pattern recognition

Local science fiction writer William Gibson turned the ubiquity of contemporary branding into a personality quirk for Cayce Pollard, the main character in his book *Pattern Recognition* (2003). A specialist, indeed a savant in recognizing group behaviour around cultural objects and ideas before anyone else does, she removes all labels and branding from everything she owns. They assault her electro-magnetic system producing painful migraines. In the story, Gibson extends the phenomenon further, describing how people are paid to mention products casually in social settings as a part of marketing campaigns. Chatter drifts across space like barely detected apparitions, floating through walls, opening doors, and inhabiting our very nervous systems. Have digital graphics morphed from the screen surface and wandered into a hallucinatory world of eternal stimulation? Is there no escape from their incessant and pervasive spotlight?

definitions: 1. haunt 2. phantasm

Conventional definitions of the verb "haunt" invoke habitation, visitation, or appearance in the form of a ghost or other supernatural being. Additional denotations suggest recurrence, frequency, or repeated visits, especially as a ghost. Indeed its Old Breton etymological origin, "hanter" means both "haunt" and "frequent." Perhaps "to be" is to be haunted, by oneself, by space, by absence, by technology, by loss, by unmeaning. An essential psychic risk, one is always seeing ghosts.

In its manifestation of subjective desire, a phantasm often eludes the faculty that differentiates real from imaginary perceptions. The life of a representation folds into the psychic process where fascination morphs into the phantasmatic giving rise to supernatural happenings and visions. In the transit between corporeal and incorporeal, real and imagined, a whole series of inexplicable phenomena occurs. The philosopher Giorgio Agamben has described this as a process in which what is real loses its reality so that what is unreal may become real. He suggests that to reach the incorporeal metaphysical world, man gives light and form to his own phantasies and masters in an artistic process what would otherwise be impossible to be seized or known. To be sure, psychic risk and inchoate desires haunt both our neural and cultural networks.

paranormal investigators

According to a vancouverparanormal.com, "proud member of the TAPS family of paranormal investigators," a ghost investigation entails an initial interview with the client followed by the use of cameras, video recordings as well as other equipment as the need dictates. While controversial and the subject of much debate, the practice of capturing ghosts through mechanical means dates back to the origins of spirit photography in the 1870s. Often photographers used a device to trip the shutter when there was a sound, a change in light, a change in temperature or electromagnetism.

haunted sites

There are numerous allegedly haunted sites in the GVRD (Greater Vancouver Regional District). These include Ceperley House at Burnaby Art Gallery, James Cowan Theatre at Shadbolt Centre for the Performing Arts and Central Park, all in Burnaby. New Westminster boasts Irving House, 12th Street, Glenbrook Ravine Park, Queens Park and New Westminster Secondary School. In Vancouver, sightings range from British Columbia Regiment (The Beatty Street Armory), The Old Spaghetti Factory in Gastown, The Orpheum, The Vogue Theatre and the Hotel Vancouver—especially the elevator when stopped at the fourteenth floor. As the door opens a lady in red is seen gliding through the hallway. And of course there are numerous related organizations, including BC Skeptics Society, BC Ghosts and Hauntings Research Society, Greater Vancouver Association for Research and Enlightenment,

BC Scientific Cryptozoology Club, UFO BC, Canadian Crop Circle Research Network: BC Branch, BC Society of Paranormal Investigation and Research into the Supernatural.

architectural phantom

Neil Campbell's Base (Machine), an LED display installed in the windows of the Vancouver Art Gallery on Georgia Street from October 2005 to January 2006, transformed the formal façade into an architectural phantom. The piece incorporated both the history of Vancouver's original provincial courthouse, a neo-classical building completed in 1912 and the gallery's possession of the site in 1983. According to the Vancouver Art Gallery's press material, "The installation invites passersby to consider not only their relationship to the building, but the nature of the institution it houses." From dusk until dawn, the flickering lights whose incandescent qualities conjure Edison's electric light bulb, made the building appear as if occupied by poltergeists. If ghosts are souls that do not find rest after death, one wonders what unfinished business lingers here? Conceivably, the pulsating lights were not metaphors for disembodied souls, but rather impressions of psychic energy left behind by the deceased. Some scientists propose that all poltergeist activity that they cannot trace to fraud has a physical explanation such as static magnetic fields, ultra and infra sound, static electric charging and ionised air.

The light emitting diodes (LEDs) turned this architectural monument into the haunting exterior of a gothic laboratory. Like the mad scientist Rotwang in the 1927 film *Metropolis*, Campbell has constructed his own M-Machine. While inanimate, Machine was a 21st century architectural automaton, programmed to perform an illusion of vigilant sentience. Drawing from an interest in abstraction and formal concerns, Machine doubled as a perceptual field and an exposition on architectural history. Do these ionic columns, central dome, porticos, ornate marble stonework and their attendant history haunt the Vancouver cityscape? The window installation addressed the electrical body both perceived and symbolic where a field of light communicated with our somatic responses. The interface was porous, modulated and unpredict-

able. Campbell's piece suggested that we are plugged into the world not only via our mobile devices but also through the experiential realm of our nervous systems, senses, and chemical reactions. The pulsating lights signified glitches in the communication signal and triggered our own bodily discovery. The erratic on/off sequence also emoted a lack of predictability, a ghost in the machine or return of the repressed. Arthur Koestler argued in his book *The Ghost in the Machine* (1967) that the human brain is built upon earlier more primitive brain structures. These residual traces, the "ghost in the machine," can resurface and override what we have come to expect as rational functions. According to Sigmund Freud, "the return of the repressed" can explain overlooked psychic phenomena such as dreams or slips of the tongue (parapraxes). Campbell's programmed glitches are themselves clues to the secret functioning of alternate, electrical realities and parallel brain structures.

fantastic media

Since the origins of electricity in the nineteenth century and the invention of the telegraph at the turn of the last century, fantastic media stories highlight how the cultural construction of electronic presence is bound to the social application of a technology. Within the context of the frontier culture of Vancouver, doublewalkers frequent the landscape particularly if one is prepared to recognize the patterns or indeed has an affinity for its detection. Indeed the cultural conception

of technology and digital media here in the Pacific Northwest has influenced a range of work produced. These include the commercial application of information and communication technology, otherworldly gaming scenarios, developers of interactive entertainment software, post-production facilities, new graduate degrees in expanded media, monthly gatherings on art, technology, and culture, and excursions in the genres of science fiction and fantasy.

b·movie science fiction

Does "Made in Vancouver" symbolize cheap, B-movie science fiction or a hospitable zone for "visitors"? Are its ambiguous and often damp streetscapes a double for undisclosed locations? Hollywood North is a phantom landscape, a city of parallel worlds, a landing strip for L.A. sci-fi projects. A motley crew of special effects designers and studios dedicated to science fiction film has besieged Vancouver. Industry mainstays for the FX culture consist of Rainmaker, Technicolor, Northwest Imaging & FX, Lost Boys Studios and Image Engine. *The X-Files, The Outer Limits, Smallville, Stargate SG-1* and its spin-off *Stargate: Atlantis* number among long-running television series shot in the city. Works for the big screen include *The Chronicles of Riddick, I, Robot, The Core, Mission to Mars*, as well as *X2, Elektra, Catwoman, Underworld 2, Fantastic Four*, and *X-Men: The Last Stand*. Allegedly, the ghosts haunting Hycroft Mansion near South Granville have "particularly detested hosting science fiction shoots, such as *X-Files*, or *Poltergeist*." Everyone has their limits.

vancouver media culture

Ideas and metaphors of the paranormal and their ties with the birth of communication technologies offer an alternative form to explore the edges of Vancouver media culture. Electronic presence, the phantom muse of experimental media, signals the overlapping cultures of communication technologies and the paranormal. The interwoven boundaries of space and time circumvent discrete modes of engagement whether aesthetic or consumer. A Pacific city of rain coupled with imagined technology has created phantastic and science-fictional scenarios; a walk in Stanley Park still echoes the simulacra of syndicated *X-Files* episodes; a fleeting glimpse of a streetscape can produce uncanny effects. The West, with its terminal destination, dissolves into the eternal return of haunted worlds and repressed desires. Technology, culture, and electronic presence are not only tools of commerce but also lenses with which to think, strategies for the alteration of ideas and landscapes. A haunted light continues to morph the fields of culture, broadcast media, futuristic and dystopian vistas, somatic structures, magnetic currents and any number of shadowy interactions.

the crux of a Pacific unknowing, or just a Shakedown of an unambitious knowing in a world that is not over its own end

the decomposition process this, the
end-o-west-o-matic inundation, clear as
day and an afternoon naked as paradise

an impasse, a crisis of sorts, has been remarked upon as of late within the ivy ghetto of late
theory

you want to say hope but as your mouth opens it's stuffed with commerce
and institutions & palliatives of the habitual middling understanding
& a positioning of antiquities, a collusion machine rigged to throttle
the affirmations of consilience (of knowledge & expression & action) of
the extravagant yet only necessary/determining/survival
—here is one negative reflection from Hal Foster:

"relativism is what the rule of the market requires" *trapolate*

my suspicion: the future is substandard as the workers are incompetents, repeat broadcasts available as
interstitials or a video lecture in rm. 202; the abuse of history ubiquitous, the phlegmatic character acts of the
fatted institutions collaborating with the status quo—collecting checks and balances and running on decadence.

Seeking an originality through a singular local awareness, and waywardly, without a desire to emulate—is it the arrogance of

isolation and of the powerless or the relief of the chockablock happenstance of truth—dirty word, to be sure.

OLIVER HOCKENHULL

Malcolm Lowry gets his eviction notice...
it was never the city, it was always the location,...

———————————————

Roy Kiyooka once remarked to me—the value of
Vancouver for artists is that it is inconsequential in
terms of the art centres of power—you can simply
do what you want without anyone much caring.

Jeff Koons*, surprise, could not have made it in
Vancouver but then again, neither can anyone else.
You are made in Berlin, in NYC, still in London, but
not in Vancouver.

*"Jeff recognizes that works of art in a capitalist culture inevitably are
reduced to the condition of commodity. What Jeff did was say,
'Let's short-circuit the process. Let's begin with the commodity.'*

Vancouver was once much less a destination than an
escape potential from the rest of the country.

It was for the sum of some of the nobodies who
came a presentiment of the liminal externalized,
a geography ready to slip away, to dissolve, and too
damn rainy and out of the way to be considered part
of western civilization. It was not an intention, it
was a contingency, a salty start to peripatetically face
the elation of the adieuing western sun.

Talking to a friend from Bangalore, I unconsciously
let slip: "Vancouver is far away from Canada"
not meaning to be facetious but factual.

———————————————

Douglas Coupland loves his Blackberry and goes to his
retreat island off "the Queen Charlotte's whenever he
can"—programs the everywhere ad

Shangri-la
not to be built
but lived

ocean determinate
smooth as sand as singular
and as same, waves that give
the idea of endless number,
the reach of life as simple
as that & tongue thick
in the mouth and wet

Philip K. Dick bumbles down a Chinatown street, his seeing moiréd by the pink light streams of the Piscean nature, hypostasis recognition — there is a lot of gutter in the new blingbling-special Vancouver.

The gutter is a place for the excess.

Oh **look**

in Russian orthodoxy the icon would be placed in a corner—a no exits of sorts, the main icon is, of course, Jesus! Jesus is unceasingly the infant Jesus, the miracle birth, and Jesus is the mythic umbilical cord for believers' rebirth.

there is, always has been, an excess of data—that is not the problem but an excess of humans is these humans that need to eat and shit, sleep and fuck and on top of that, ridiculous—they want to mean something.

"the image is not a state, a solid and opaque residue, it is a consciousness."
—Sartre, l'Imaginaire

the world too much with us

images are for the infantile, they zygote us into our lovely others bloody organs.

the innocent eye, a Brakhian eye—recalling the American Emersonian transcendental tradition—recalling the blue flowers of German romanticism, an originating ignorance, blinding light of incomprehension, and the continuing of enquiry before naming

Images, pure—yes, pure—are structurally, psychologically a means for the rebirth of the infantile. Icons=Images=Icons thus unceasing duplicity, multiplicity, and necessarily polytheistic.

What's that?

All images represent, and in representing—hey presto, mashup to be mirrors.

catoptromancy*

The West is a society ruled by
*divination using a mirror or several mirrors

screen saver of the blank mind ecstasies in the trance of its bio activism—scarred by the sublime and then thrown off the cliff by the unadulterated noble lies, regimes and sociologies, and a civilization of play-doh realities and hell in a hand basket arrives with brand flake regularity.

An imaginary radico Islam is the bizarro world opposite, iconoclastic, allowing solely an invisible immobile intricate series of rules to recall (or allowing practitioners to exist in?)

—the infinite

and where even the buddha's statues must be howitzered

image e for the fantile

the word meaning comes from the word moaning

moan everything, mean everything

total meaning as total submission as total warring and as total eradication of self as religion

the marker of time, the image, is the production of observation

Islam is by far the fastest growing religion on the planet and certainly one of its appeals is its antagonism to the obsessive image addiction of the West, idiophilia and the West's perpetual revolutions, its devotion or rather its slavery to time (time as bought and sold moments and mortgages of image moments)

So, famously, what to do?

observation is the twinning of the phenomenological and the informed

"BY SEA LAND AND AIR WE PROSPER" —motto of the City of Vancouver

plasticity—institutional and individual, in form and practice—a merging of need and a wealth of imagination—responsive and responsible—an economy that fosters only the radically associative

it is not that information is free, or wants to be free, it is that it is available

Vancouver's history of anarchist interventions and activities, its idealistic delusions, in fact, is what made the place different. It was its singular difference that made a difference.

information does not create the informed, only a set of ideas can do that

the pre-eminence of the image in capitalist society is a commodification of a dromological marker—the exchange is my time for your presentation

now everyone illimitably knows that their time is going to be limited; that's the main reason everyone loves disaster porn— every frame a money shot

production is the means from which theory (order and engagement) is met.

"How long can a coincidence extend before it ceases to be one? Does coincidence have to be momentary? How long is the moment, the ongoing moment." —John Berger, quoting Geoff Dyer, in *The Ongoing Moment*

the grounding paradox of a timely disjunction in time, a herald of modernity in all its confusions, glories, hyperbole, violence, meaning and non-meaning, the beginning of the recognition of the value of noise and chaos, that function of dislocation that refuses the tag of meaning by being it and not-it...

information is everywhere, the ongoing coincidence, film unbound by time, unbound by celluloid, by narrative, unbound to screen, and unbound by a lens, unbound to celebrity, understanding the ubiquity of the moment, the flash as the shared, the shared as the algorithmic. Marey predicted, and in 1879 documented it: all the horse's hooves are off the ground, gravity suspended, and the whole damn horse hovers!

"A revolution normally lies ahead of us and is heralded with sound and fury. The algorithmic revolution lies behind us and nobody noticed it. That has made it all the more effective—there is no longer any area of social life that has not been touched by algorithms.

Over the past 50 years, algorithmic decision-making processes have come very much to the fore as a result of the universal use of computers in all fields of cultural literacy—from architecture to music, from literature to the fine arts, and from transport to management. The algorithmic revolution continues the sequencing technology that began with the development of the alphabet and has reached its temporary conclusion with the human genome project. No matter how imperceptible they may be, the changes this revolution has wrought are immense. The revolution might almost be equated with an anthropological turning point, because—a further narcissistic insult [Copernicus, Darwin, Freud]—it wrests the initiative from nature and mankind and replaces it with an automatable inherent law of action. The illusion of sovereign action on the part of the individual and the romantic notion of anthropomorphic decidability are tempered as a result."

ZKM: Center for Art and Media Karlsruhe—*Algorithmic Revolution* (http://www01.zkm.de)

EXHIBIT

"The transnational elite, professionals and business people living and working in several global sites and involved in the control of capital and information flows between these sites, negotiate the new spaces of 'late capitalism' to their supreme advantage. One highly successful real estate agent spoke of the efficacious use of the fifteen hour time difference between Hong Kong and Vancouver. With an immediacy of communication juxtaposed with a real time lag she is able to maintain nearly continuous buyer-seller information and connections."

"Multiculturalism, or the United Colors of Capitalism?"
Katharyne Mitchell, Ph.d., University of California, Berkeley

"Life starts at $300,000."
—Vancouver Condo Billboard

"I knew plastics had a great future."
—Li Ka-shing

writerly, we are living in a linked world, however that linked world is circular, the gravity of hubs effecting the weight of our communications allowing them greater or lesser social value and thus conditioning their utilization.

—See: 80/20 rule / the The Pareto Principle—

individual creative nodes spin off to orbits yet alien far from the concentric focus of disciplines—interests conforming to the demands of collective, historical, and plainly ideological pressures...

we can also presuppose that innovation is the recall of a circular system of reference, yet that reference is of the transport architecture of movement itself...the movement is at first elsewhere and then becomes, if successfully adopted, eventually ubiquitous.

talking big time referencing, weather permitting Vancouver as minor hub, its motto:

"BY SEA LAND AND AIR WE PROSPER"

Questions about the future of humanity have a descriptive and evaluative component: what awaits us, and what should we do?

Where a social formation originates it continues to bear all its contradictions.

my days are spent measuring the height of walls with my eyes. *diderot*

meaning 2: it is possible to propose and work towards utopian gambles—
social, technological, psychological, material— this is not ideology, it is
what valid work is about

a culture of innovation requires meaning to become an
infinite series of approximations

innovation is an idea in the head, a frail bubble
glistening back the curvature of the wants of the
world yet mirroring an aspired to completeness

not a school of artistic production, nor a salon of
manners, repetition, tracing and masters, nor an allegiance to the
finalizing of identities (an unconscious predilection
towards body bags and the all importance of name
tags)— but rather not this, not this, not this

The proper horizon of the phenomenological reduction is neither
presence (Husserl's reduction), nor being (Heidegger's existential
reduction), but givenness (Gegebenheit, donation) (Marion's reduction)

the Cloud of Unknowing based on the
certainty of Grace—Grace, the givenness of life itself.

Quoting McLuhan: "You should know what the stakes are. The stakes are civilization versus tribalism and groupism, private identity versus corporate identity, and private responsibility versus the group or tribal mandate." He said this in relation to the transformation from a literate culture, a culture conditioned by its use of a phonetic alphabet, a culture that encourages private identity to a culture of simultaneous information; the culture of simultaneous information is role orientated rather than goal orientated.

lost in roles rather than having goals

the etymology of the word radical refers to 'root causes'—a radical film makes the search for causes its modus operandi.
Vital aesthetics.

a film that portrays only conveys a performance of attitudes and postures of various ideological and psychological myopias...the camera frames and the subjects become objects—we know this intrinsically, it's second nature, death at work, stealer of souls, the husk of self, the normal film.

"The broadcasting and production of images has as its goal not the opening of a world but rather the (en)closure of it by a screen; the screen substitutes for the things of the world an idol constantly repeated for viewers, an idol multiplied without spatial or temporal limits, in order to attain the cosmic scope of a counter-world. The televisual image, structurally idolatrous, obeys the viewer and produces only prostituted images."
—J-L Marion, *The Crossing of the Visible*

appearance becomes a substitute for

everything.

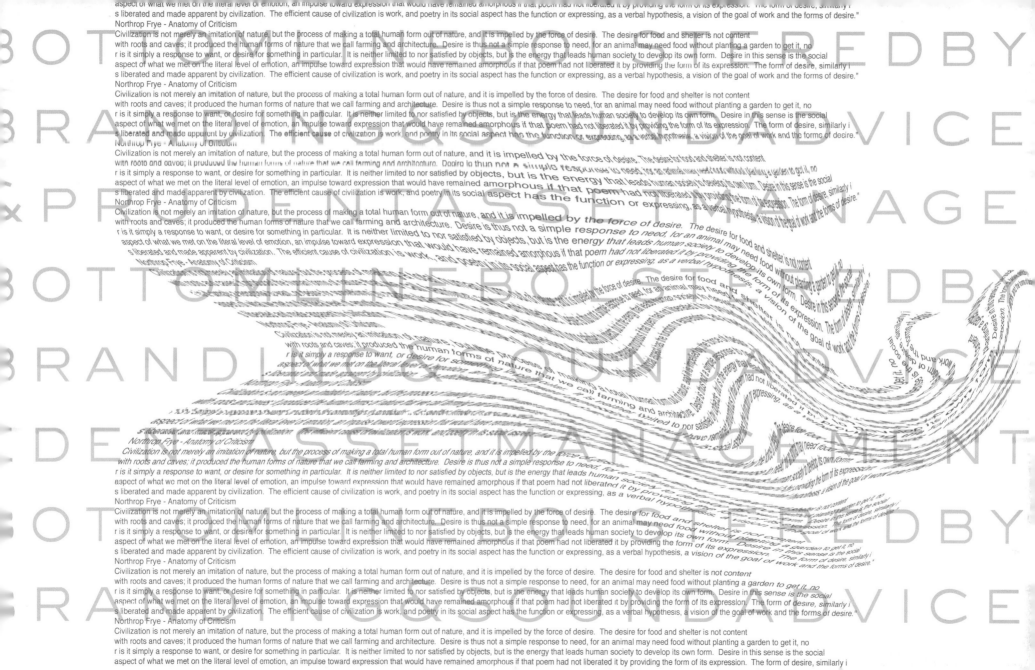

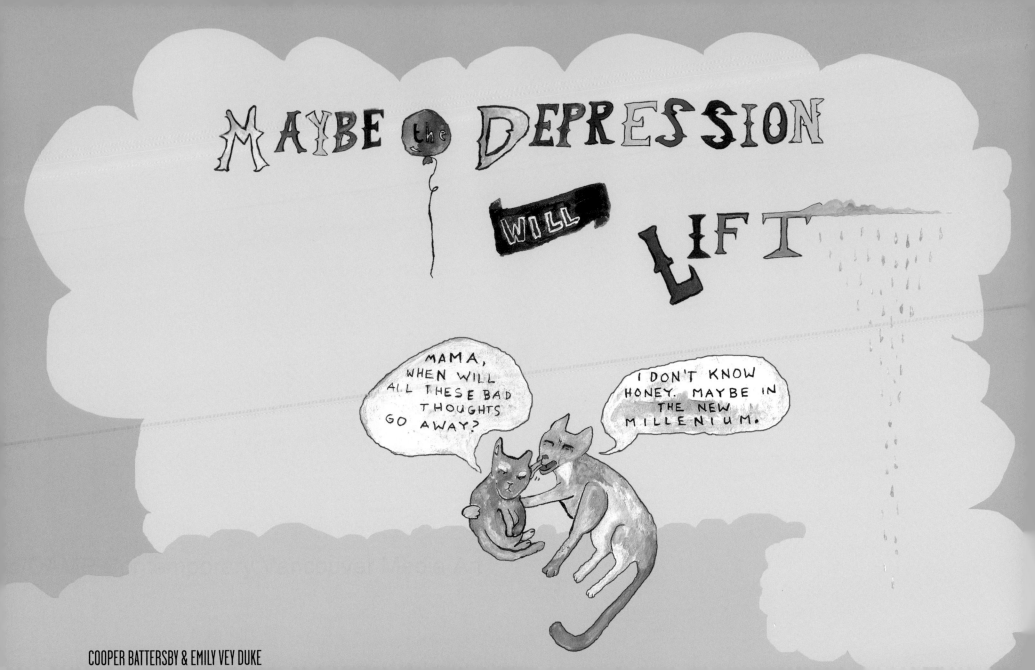

New Media and Narrative

or

"Why Are There No Seats in this Gallery?"

Somewhere between the simple, documentary films of the Lumiere brothers and the early historical epics of the likes of D.W. Griffiths and Edwin Porter, cinema became the 20th century's most popular medium for storytelling. In the process, it developed a distinct visual language and ritualized space that has shaped many subsequent forms—from the likes of television to the internet to new media. Media arts in particular have appropriated many of the conventions of cinema—often using the language of film in order to deconstruct narrative. By extension, the video installation/media artist has in some ways superseded the experimental filmmakers of the 1960s, '70s, and '80s—exploring the structures and concepts borne out of these new media from a more or less theoretical perspective. What I personally find curious is that the opposite situation seems so rarely undertaken. Specifically, that New Media technologies (software, purpose built systems, multi-channel projections, etc.) are not more often employed in the construction of narrative.

By narrative, I am talking about the kind of story structure that naturally invites reverie and digression—where creating a mood or even an aesthetic are as important as hitting plot points. It is the kind of work that exists as a complete artistic gesture—containing elements of story and characterization—that I think is so appropriate to the forms of media arts. These are films unrushed by plot, content to meander through moments of visual beauty, aural daydreams, and tangential characterizations. In fact, the way you might consider viewing these films is akin to the way media arts/installations are traditionally exhibited: there is no expectation that viewers will sit through every cycle/permutation of a given work. Rather it is something to be revisited—accessed for shorter periods, but, perhaps, more frequently. It's no coincidence that there aren't any seats in art galleries.

BRIAN JOHNSON

From: Alex
To: Brian
Subject: essay version

thanks for this new version brian. your material has been percolating in my head since i first read it. i have a few thoughts about it finally, and so following are my spontaneous notes, off the top of my head—apologies for jumping around. and all taken, of course, as a dialogue to further investigation...

why is new media technology not used more often in the construction of narrative? well, economically it would make perfect sense, and likely will get swallowed up by hollywood (and dribble down to telefilm) soon, once they get the idea that they are being usurped by it as we speak. but forget hollywood—new media is already being used by the video game industry. gaming has far superceded hollywood both in terms of popularity and market share and it is precisely these technologies of variable narrative, player controlled "journey" etc that are taking advantage of new media systems. (i don't have exact figures, but something like 3 times the size of hollywood is probably about right, likely more).

so your dream is a reality—and look what it has wrought. the local filmmakers of whom you speak, so reverent of the feature film, are in fact a dying breed, in the stone age. the latest generation of "storytellers" are already out there making big bucks right now at Radical, EA, et al. Vancouver is the epicentre of a lot of this action. and so the new economic dream factory model does exist. and guess what? it ain't that interesting—just like hollywood wasn't.

and that might have something precisely to do with the problem of story-telling.

one of the things that (personally) is striking a chord for me in your essay is the whole question around narrative itself. maybe the reason variations on narrative aren't being pursued more in galleries is because people in galleries and the like (artists, i mean) are looking for something else—an alternative to the [historically] theatrical and novel-derived paradigm, something that moves away from "storytelling" and into a different territory. your initial premise—that media arts have appropriated many of the conventions of cinema—may be true, but using the language of film does not necessarily mean deconstructing narrative. the language of film exists quite apart from narrative, if it chooses to. this was the primary function and drive of so much of the experimental work produced in the '70s/'80s—to get away entirely from narrative, moving past it, not with it. stepping out (non-reactively) into other territories utterly—sculptural, for example (and primarily).

ironically, and counter to your frustrations, the bulk of known [read: visible] video installation/media art currently is, in fact, (sadly?) responding to hollywood—feeding off of it—riffing on the dream factory and all its romantic baggage (think douglas gordon, pipilotti rist, mathew barney, eija-liisa ahtila and i'd count local boys rodney graham, stan douglas, and jeff wall)—possibly critiquing it but still using it and playing into and with narrative.

in the other corner, the people seeking funding, spinning their wheels in development-land for their features etc. (a different breed you might say), simply aren't interested in questioning or stepping outside the bounds of the restrictions of the system (read: economic/hierarchical)—nor the limits of narrative. they only wish the system was easier to negotiate. they were fed it and want to keep the dream alive with their romanticized notions of indie director and all that entails, and they are encouraged to do so.

i guess what i am saying is that the reverence afforded to feature films of which you speak is bound up in the reverence afforded to narrative in the first place.

there is no room for the possibility of something other than narrative, no matter how you choose to spin narrative, it is still narrative. that said—there is nothing inherently wrong (for me) about telling stories, and i think it serves a function in any culture, but it certainly doesn't do justice to the potential of imagination or modes of human expression. it only caps potential. i think your ideas about how (telefilm, say) could better use its funds in forms of cultural production and exhibition versus development are fair points, but realistically, the model is not one of arts, it is one of business. the economics of artmaking

The fact that more filmmakers aren't pursuing alternate media arts forms is all the more perplexing given the marginalization of our local, indigenous narrative film culture. The sad fact is that Canadian English language cinema is a false economy. In 2005, English Canadians only saw domestic films 1.1 percent of the time—this in spite of Telefilm's policy of only funding films with a demonstrable box office draw while avoiding "auteur" films. Here's an idea: develop and produce better films. Telefilm cannot, however, be blamed for ignoring emerging media and technologies. Their corporate plan for 2006: From Cinemas to Cell Phones: Telefilm Canada Responds to the Multi-platform Challenge suggests the awareness of new, cinematic spaces—as does the $14 million earmarked to the Canada New Media Fund administered by Telefilm. The question remains, why aren't we seeing more narratively structured Media Arts projects?

Maybe a more substantive paradigm shift among artists and feature filmmakers is required—one that expands understandings about what cinematic experiences might be. That filmmakers in particular would be anxious to embrace new forms for the expression of narrative cinematic art making shouldn't be in question. In Vancouver the impetus should be all the more great given our peripheral position to both American and Eastern Canadian centres for development and financing. Couple this with the prevailing sense of malaise found generally in cinematic culture, (declining box office numbers, increasing corporate control), and the difficulties found in mounting homespun productions becomes increasingly prohibitive. Again, this presupposes that getting a film made will in and of itself entail people actually seeing it—a fact that is unfortunately far from the truth in Anglo-Canada, and Vancouver especially. At some point our local filmmakers must question the reverence afforded to the feature film. With so many hurdles placed in the way of its production, and ultimately so little payoff, how can producers and directors not be looking for new forms of expression?

New forms will of course imply new venues and systems of distribution, but then our indigenous film industry has little access to these services as they exist now anyway. Smaller, more modest productions are ideally suited to smaller venues—promoted locally with the assistance of artists and gallery operators alike. A true paradigm shift occurs when Telefilm comes onboard, supporting more projects of smaller budgets, as well as the venues themselves. It seems to me that in doing this they create a culture of production and exhibition rather than a culture of development, and quantity alone can go a long way to creating at least a sense of a vibrant, vital community. This shift in the mindset of film producers and directors doesn't in and of itself entail engagement with media arts forms, but it does seem to allow more room for the freedom to explore. By example, former small venues here in Vancouver, such as The Blinding Light! and the Sugar Refinery, allowed artists a forum in which they felt comfortable to experiment with a variety of new systems and forms. I can personally attest to the fact that not all of these experiments were successful, but what was successful was the fostering of a new and strong

and the models that either allow or don't allow for a revenue stream demand but a brief glimpse at arts funding in canada to see that it is a very low priority from a gov't perspective. no answers here—just questions. all for now.... is this useful?
-alex

To: Alex
From: Brian
Subject: re: essay version

Alex,
Just because you engage narrative doesn't mean you have to become a slave to its tyranny. Take Satyricon. Here's a narrative film (sort of, I guess) that's really a motion picture painting! How could that possibly cap anybody's potential? In a single shot *Fellini* creates something more stunning and rich with emotion than all these fucking new media wankers—plus there's a story there if you care to follow along. (For the record, I don't, and this is the kind of cinematic experience that I'm really trying to promote.) We actually are creating narrative all the time—and then slip off into a reverie about something else—politics or something—and then we check out a hot chick—and then we create a little narrative about that for awhile. There's kind of just this great wash of images, stories, recollections and abstractions of the whole gory mess going on all the time. It doesn't have to all be a part of Hollywood's grand narrative. That's not the point. You engage in story, for a while, because people need it. Then you take them off in another direction.
I thought about the whole video game thing, but it hardly seemed worthy of mentioning. Yah it's narrative I suppose, but the most crude, un-artful kind imaginable. I sort of didn't want to even give it the press...
Telefilm spends a fuck of a lot of money on mostly crappy films. This is why I primarily focused on Telefilm. Yes they try to run that fucker like a company, but it has never and will never make any money! So if that's the case why bother. Why not focus on high concept, auteur art films and at least try to make interesting stuff. Doesn't it seem ridiculous that their official mission statement seems to rule out the possibility of the above being funded?
Anyway, it's 2 in the morning and I worked about 14 hours today. Making some great narrative cinema for the aforementioned Hollywood cocksuckers.
xoxo B

To: Brian
From: Alex
Subject: re:re: essay version

hey bri
i hope you got some sleep and didn't dream the factory.
i take your points about the potential for narrative to be a jumping off point (and certainly it isn't all hollywood). if i have a bone to pick with narrative it isn't one that excludes it, but rather one that says this isn't the only way things can be expressed—and there are plenty of examples of this that have nothing to do with experimental film. the majority of dance, music—christ even some of the better rock videos don't even begin to tell any kind of "story", but rather evoke a state, a quality, render beauty in its most potent and simple terms. while i may agree that we are often creating narrative day to day in our lives, i actually suspect (and i am not the only one, not by a long shot) that this is a product of cultural/economic imperatives, and not a natural mode of human thought. plenty has been written on the subject, so i won't get into it here.
you take issue with the very "new media wankers" you want to

community. Current venues such as the Vancity Theatre and the Infinity Features cinema at 319 Main Street have the potential to carry on this tradition, but smaller, artist-run galleries and the like must also continue to be seen as viable venues for the exhibition of cinematic art. At the very least if the locus for cinematic expression were to shift from the multiplex to the art gallery, local filmmakers would not be in direct competition with the cultural juggernaut that is Hollywood.

That leaves audiences. A "build it and they will come" attitude is probably a little naïve—leaving producers with the age-old issue surrounding Canadian film: how to get people to see the stuff and how, by extension, to create a revenue source. The latter of these issues becomes particularly sticky given that galleries don't normally even have an admission fee. Is it possible for directors to be a little more proactive in terms of creating this revenue stream? Some artists, such as Mathew Barney and Stan Douglas, do so by taking a more holistic approach to the entire production—artifacts, stills, and sculpture used or created in conjunction with the video installation/film become the art object. This is obviously not going to be the magic bullet, but I think it suggests the kind of initiative and creative spirit that we need in order to get stuff made here. Once you create a culture of production and exhibition you create the sense that something is going on, and people do tend to get caught up in that. Moreover, I think that a modest, grass roots approach to both production and distribution will reach as many viewers as our current feature film systems, while allowing for a greater plurality of voices. These voices will also seem more personal, speaking directly to audiences from within venues that are part of a greater community as opposed to a greater corporate conglomerate. Indeed, we see many other industries and organizations being encouraged to restructure in similar ways—moving from large, top heavy, centralized bodies to small, quickly responsive, regional ones. For a long time Canadian film insiders have indicated the pointlessness of local, independent filmmakers trying to compete with American blockbusters. So why not work in a way that radically distinguishes local work? If the thing isn't going to have the trappings of what viewers have come to expect from cinema, then let's break out of that narrowly defined form. Work that engages new media technologies as a way of constructing narrative doesn't have to "look" like a Hollywood film because it is so clearly not about that. Couple this formal innovation with a system of distribution that puts work into smaller, local galleries and cinemas and you will build audiences. If all else fails, serve beer.

In truth, there is no shortage of talented people and resources in Vancouver and much to be excited about. Some people are of course already exploring the narrative potentials of media arts with success both here at home and abroad. However, one can't help but feel that there are many talents being squandered, waiting to reel in the financing for their next feature film. It's time these talents were applied to alternative forms, no less valid, and in fact possibly more so. For what could be more significant than to describe a new space, with its potential for ritual and magic—where story can unfold.

transform, the not-making-feature-films-and-waiting-for-funding filmers into. so maybe pick that bone a bit more—even the marrow.
 questions of how bound to systems we are, how much these systems determine our actions, and if output becomes reactive instead of based in ideas – these i think are ideas worth exploring.
 i am more than happy to forget hollywood, and only reference it here as a way into the "dominant" form, but your frustration with the system and telefilm is also the frustration you feel in and with your peers who are party to it, no?
 "You engage in story, for a period, because people need it. Then you take them off in another direction." —yes, this does and can happen (tho not necessarily).
 But is any of that going on here in vancouver?
 Is your frustration with the system, or the kind of work being produced regardless of the system? Is the system (read telefilm) to blame? Any of us are welcome to make any kind of art we like. So what is stopping us (them)?
 there is a separation between industry models and art models, and crossing these over can be a compromise, a cashgrab, and at worst a failure and disrespect for the work—the thing that is supposed to matter the most in the first place.
 talk again soon...
 a

To: Alex
From: Brian
Subject: re:re:re: essay version

Alex,
 Just back at the celluloid salt mines. Not too busy as I'm just doing "b" camera—which means I mostly sit on the camera truck reading, sending email, and writing this confounded DAMP thing. See, Hollywood is good for something!
 So I'll grant you that narrative, at it's worst, can be a product of economic imperatives; and that sometimes the cultural motivations for it can be dangerous. However, I think that there is a much deeper need within humans to engage in narrative. It's the same instinct that causes us to find faces in clouds and figures in completely abstract works of art. Clearly there is a deeply situated need within people to find commonality with other humans, which is ultimately about not feeling alone in the universe. I think that this need is so great within people that we are actually very vulnerable to it being used in ways that can hurt us. It's a black magic, that storytelling, which is probably why the narratives of some oral cultures were not for general ears to hear. Interestingly, dances were also kept secret by some of these oral cultures. The Nu-Chah-Nulth right here on the West Coast have dances that to this day are reserved for their eyes only.
 I would say that the implications for Vancouver are fairly simple—we need to try harder to make more interesting films. And although the systems do seem to be working at odds to this becoming a reality, (let me again remind you that Telefilm—the system for feature filmmaking in Canada—has publicly stated it will no longer support artistic, auteur driven projects), the means of producing fairly high quality work has never been so attainable—it just needs to be used in innovative ways. Which brings us back to media arts. And also venues.
 And yes the frustration I feel with Telefilm is also the frustration I feel with my peers—but I hope that comes across in the essay. Does it?
 forever yours in debate,
 Brian

The Imaginary Network

Peter Courtemanche

1. John S. Belrose, "Reginald Aubrey Fessenden and the Birth of Wireless Telephony," IEEE Antennas and Propagation Magazine, Vol. 44, No. 2, April 2002, pp. 38-47.

2. Velimir Khlebnikov (translated by Gary Kern, 1976), snake train, excerpt from "The Steppe of the Future", 1915-16.

3. Bertolt Brecht, "The Radio as an Apparatus of Communication," translated by John Willett, in John G. Hanhardt, editor, *Video Culture: A Critical Investigation* (New York: Peregrine Smith Books/ Visual Studies Workshop Press, 1986), p. 53. Requoted from Anna Couey, "Restructuring Power: Telecommunications Works Produced by Women", published on-line at http://www.well.com/~couey/, 2001.

1. Early Dreams: Marconi, Fessenden, Khlebnikov, Brecht, Mann

Many early dreams about radio and telecommunications predicted a system that would be open, multi-directional and shared. In the early 1900s radio was in its infancy. Marconi and others constructed huge spark transmitters that could broadcast very simple Morse code-like messages over the Atlantic. Each transmitter had a unique sound signature. Radio worked much like early telephone "party lines" with receivers that picked up a broad range of overlapping signals (and background noise). Operators listened for the differences in the sound signature in order to discern individual sources. In December 1906, Canadian engineer Reginald Aubrey Fessenden[1], broadcast music and voice using an enhanced version of the spark transmitter. Fessenden went on to develop the theory and practice of continuous wave transmission that we use today for AM and FM radio broadcasts. But in 1906, the ships and coastal stations that communicated with key codes were astounded to suddenly hear a ghostly human voice coming out of their ear-sets.

During the early days of radio, notions of the broadband receiver led journalists and poets to imagine radio as a global network often bordering on telepathy. Radio would bring all peoples together in a giant communications network that would aid in the removal of misunderstandings, cultural collision, war, etc. Radio would move stories around the world, it would save boats at sea, it would democratize journalism and politics. Radio would enable mankind to achieve its ultimate goal of reaching into the afterlife to talk to the dead. Mankind would evolve a new consciousness. (One of my favourite poetic images of the spark transmitter

as democratized radio comes from "Snake Train" by Velimir Khlebnikov[2]. In 1915, Khlebnikov imagined an elaborate system of writing on clouds. This "sky writing" would be fed by spark-messages from fishing villages along the Volga.) In some ways, Fessenden brought about the end of this dream when he made it possible to broadcast and receive on a single narrow frequency. Fessenden believed in broadcast to the masses. By the early 1920s, the broadband era of radio was over. In 1932, Bertolt Brecht proposed a restructuring of radio: to "change this apparatus over from distribution to communication"[3]. This illustrates that within the space of ten years, the broadcast model of radio had become embedded in Western culture. Radio was still used as a two-way system in shipping, the military, radio-telegraph systems, CB, etc., but the idea of a larger system that would be accessible by all and thus "a network" had been lost.

Starting in the 1960s, telecommunications networks (pioneered by HAM radio operators, scientists, and artists) went back to some of the early ideas of network as a shared communications space. This is somewhat ironic given that the telephone lines used at the time were very much point-to-point connections. The network was created by opening up many telephone lines at the same time through an elaborate system of relaying messages from one point to another. The relay network was enabled by audio and video recording technology. At any particular node the artists would: make the phone call, record the exchange, hang up the phone, make the next call, playback the recording from the previous call, record a new exchange, etc. During these events, the network invariably became a vast, ephemeral collage where the playback of recordings would be interrupted and altered with each new transmission. Faxes could be altered with the pen, sound and video could be layered, the

sound works and written texts (poetry, manifestos, historical documents, etc.) that would be read live on air. In this way, it encouraged an "open source" or democratized approach to the networked-radio form.

5. The Integration of Old and New Technologies

There's a growing recognition that the culture industry is doing for our culture what the forest industry is doing to our forests. The Big Media want to sell us 500 more channels where 'interactive TV' means you get a 'buy' button on your remote. On the net there are an infinite number of channels; every viewer is also a transmitter, and this has seen the blossoming of an incredible on-line culture. We hear that in the future we'll be able to send video over the phone. I want to prepare for this by using desktop video technology, low-power transmitters, VHS cassettes, the Internet, and whatever means necessary.

—Jeff Mann, article about *TV Freenet,* FRONT Magazine, volume 5, number 4, March/April 1994.

Contemporary Telematic art (art using computer networks) from the Western Front, Kunstradio and other progenitors of this form ultimately refer to (and sometimes include) other mediums of exchange: old communications technologies that are "semi-simulated" on the Web, radio networks, pirate broadcasting, telephones, satellite transmission, etc. Each medium or method of sending sound and image over long distances has its own peculiarities and its own history in terms of its use by artists. Early works used text, single-line telephone connections and modem tones to transmit video images and MIDI information (musical notes encoded as digital information). *Telephone Music I and II,* in the early 1980s, encouraged artists to compose music that fit within the frequency limitations of the phone line. In 1991, *Text, Bombs, and Videotape*—a reaction to the Gulf War—had one of its most interesting manifestations as Fax-Art: collages and hand-drawn protests, scattered around the world by Fax, often altered and sent onwards.

On the Internet, software and software development become a key feature of this type of work. Software is used to create collaborative frameworks, to incorporate different (often older) technologies into these frameworks, to enable autonomous-seeming software organisms to seek data, etc. One example is *Scrambles_Bites,* produced at the Western Front in 2003. *Scrambled_Bites* played with the idea of a "data stream" connecting robotic devices, sensors, and noise makers in different locations around the world. Here the idea was not to become transfixed with the Web as the focus of network activity, but instead to use the Internet as a means of shipping data from one location to another, to be activated in a space with a live audience. One of the inspirations behind this project was an interest in subverting the concept of Internet streaming at a fundamental level. This was done by introducing a new self-defined form of streaming and reducing the entire system to something very minimal. The *Scrambler* (our homemade server software) did not stream audio or images. Instead, it transmitted a slow collection of numbers that were largely abstract and removed from their origins. The Internet and communications technologies in general, can rapidly become vast, complex systems. The intent of the *Scrambler* was to strip back this complexity to reveal the basic underpinnings of data flow, exchange, and intersection.

23. Radiotopia (2002), quote from the "call for participation", posted on-line at http://www.kunstradio.at/RADIOTOPIA/

A certain amount of early critical writing[24] (c. mid-1990s) about the Internet was fascinated with bandwidth, virtual communities, and networked Virtual Reality. The world would be such an amazing and wonderful place when we could finally push full-frame, multi-dimensional video through an Internet connection enabling people to live in each other's imaginations (or imaginary living rooms). Some people view the emergence of cable-modems as an important leap forward in the history of the Internet. Others take a different approach and view "access" as the most important historical change in the '90s. Ultimately, a network is made up of individuals and for the network to have a significant impact on society, a significant proportion of the world's population must be connected to the network and be able to participate in its cultural structures. This idea of accessibility is key to networked radio art, both in terms of audience and in terms of enabling remote participants to collaborate from disparate cities and cultural milieus.

Designed in the era before the ubiquitous cable modem, the .. *devolve into* .. pieces were achingly conscious of bandwidth. In any work of this nature, it is important to enable both the artists and the larger public to access a high degree of depth and complexity on a connection that may be slow and prone to disconnection. Within this context some ingenious work has been done. In the '70s and '80s when artists were working with Slow Scan TV—where it takes up to forty-eight seconds to send a single frame of colour video over a telephone line—live animation (and interference) was the pinnacle of the art form. On the Internet in the '90s, using the browser's cache effectively enabled you to send little pieces of sound and image over a 14400 baud modem and have the receiving computer use those tiny segments to create something that had the sound and look of a

denser, more complicated broadcast. .. *devolve into II* .. played specifically with these ideas and techniques by managing live and recycled content and running simple generative algorithms to create a landscape that felt much bigger than the original pieces that were fed into the system. The first version of the piece from 2000, played with questions of predetermined navigation by forcing the browser to travel through an ever-changing matrix of works in order to find all of the different streams. Architecturally, the premise was simple, providing the browser with four routes from each "room" in the system to other rooms. .. *devolve into II* .. (2002) produced in collaboration with Roberto Paci Dalò and Kunstradio, focused additionally on ideas of the ephemeral (live streams) versus the document (recordings of those streams), and the notion that all digital material will eventually mutate (as it is copied and moved from archive to archive) and go through a process of decay over time.

Clicking In,[25] a collection of essays edited by Lynn Hershman Leeson (published in 1996), includes a number of different views of the network and virtual reality from the mid-'90s. One thing that I find interesting is the fascination that many of the academic authors had with MUDs (multi-user dungeons / multi-user domains). MUDs at that time were generated entirely with text. A participant would log on, create their own persona, create elements of the environment, and then navigate through a text-based game world to meet and interact with other participants. The MUD (and other interfaces for social interaction on the Web) provide a way for people to be social while at the same time anonymous (if that's really possible). The virtual social space allows people to leave fear of rejection based on physical typecasting behind. It doesn't necessarily allow one to leave other types of prejudice behind, but ultimately one enters a fantasy world

24. Lynn Hershman Leeson, editor, "Clicking In: Hot Links to a Digital Culture", Seattle: Bay Press, 1996.

25. ibid. "Clicking In".

constructed by a collective of a few hundred people who gather there to share common interests. It removes from the map all of the billions of people who don't share those interests.

Reverie (2005) was a virtual city of sound-art on the Web. It referred to William Gibson's "Walled City"[26] and other non-fictional on-line virtual communities (MUDs, chat groups, networked gaming groups, BLOGS, etc.). "Walled City" exists as a distributed network game that requires continuous human interaction to keep it alive and functioning. The players adopt a persona and take responsibility for maintaining different parts of the city. These parts are then passed from player to player as the participants log-in and -out of the game. In a similar fashion, *Reverie* imagines a city that is activated purely through the ongoing activities and exchanges of sound artists. This project was initially inspired by an early version of antarctica.ca (a map of Antarctica that acted as an interface to organizations and information on the Web) and Alien City (http://alien.mur.at) an artwork by Alien Productions created by Austrian artists Martin Breindl, Norbert Math, and Andrea Sodomka, that explores the concept of the city as a dynamic, evolving place for exchanges and cultural practice. An early proponent of the virtual city, within the context of communications technology, was Hank Bull who invented *Wiencouver*. *Wiencouver* is a virtual city in space that was developed in the late 1970s and early 1980s. It became the basis for one of the first consistent series of telecommunications events that linked artists around the world and created a community through long distance exchange.

> Wiencouver *is an imaginary city hanging invisible in the space between its two poles: Vienna and Vancouver. Seen from Europe, both cities are at the end of the road, one on the Pacific Rim of North America, the other just 65 km from the Soviet Bloc. They are each on the edge of the art world's magnetic field, able to observe from a distance, and equally able to turn the other way, one towards the far east and one towards the near east. Vienna and Vancouver are wealthy, regional cities with international perspectives. This, coupled with their linguistic and historical differences, makes them ideal for correspondents.*

> —Hank Bull, the original proposal for *Wiencouver*, 1979. Published in *Art + Telecommunications*, edited by Heidi Grundmann, Vancouver: The Western Front Society, and Vienna: Blix, 1984.

6. The Fast Future

By creating network projects that refer to earlier (pre-Internet) experiments and models, we can explore the larger history and context of this shifting realm. One of the reasons to embed seemingly archaic technologies in with the new is to imply that perhaps the world isn't evolving as fast as we think it is. There are more and more new products every day—but the idea of "product" is far from new. There are more and more software tools—but the concepts of software and hardware, biology and consciousness are also very old. What we are seeing as technological leaps are most often improvements on existing ideas—make the hardware faster, smaller, cheaper, more disposable; make the software bigger, flashier, more complex, more essential to work-flow, less compatible with older versions.

26. "Walled City" was described in *Idoru* by William Gibson, New York: G.P. Putnam's Sons, 1996.

I stopped programming computers for about six years from 1988 to 1994. When I returned to it, mostly out of interest in the Internet and the potential of networking, I was surprised to see how little had changed in that time. The structure of the Internet (its raw underpinnings) was almost identical to earlier network protocols, operating systems were much as I remembered them. The rapid development of the Internet seems mostly in the area of interface, tools, and toys, rather than in structure. This had a great effect on my view of technological development. Obviously, the notion of rapid development of software and hardware is evident in usage and access, but is not necessarily reflected through or into changes in the basic paradigm or structure of the system. I realized that transcendent development (changes to the fundamental building blocks of a system) isn't necessarily about speed, bandwidth, etc. but is instead about ideas and experimentation. From that point of view, I don't worry about having access to the latest technology. What I am interested in is access to ideas and the time to explore them.

One of the most fascinating aspects of change within contemporary cultures is our relationship to software. Software has its origins in a very particular scientific-military-industrial ideology. It mutates, expands, works its way around the world and into many aspects of life. It affects the way we work, the way we play, it creates a peculiar symbiosis between the machine and the "user", a symbiosis that alters our consciousness and cognitive processes. We change our languages so that software can encode them more easily. We change our methods of remembering and relating stories—from mnemonics, to the printing press, to the word processor. To what degree is this a process of enlightenment or, ultimately, cultural reprogramming? One of Kunstradio's most interesting (and ambitious) early

Internet (net-radio) projects was *Sound Drifting* (1999). It "was formulated as an experimental non-biological organism: a network or community of generative algorithms constituting a virtual autonomous organism living, interacting, breeding and ultimately dying in the matrix of the Internet."[27] *Sound Drifting* referred to the idea that all complex systems have an inherent intelligence and consciousness, even if the human mind and body is unable to measure it or relate to it. *Sound Drifting* also referred to the ephemerality of networked communities and saw this as a natural phenomenon. If the network exists as communication and exchange (real-time occurrences) then the network does not exist when the communication ceases or fades away—in the same way that a dinner party is over when the guests go home. The existence of ephemerality in the network can be a point of difficulty in many network art projects. In most of the projects I've done on the Internet, the artists want the work to live on without them after the project has finished. What is this fascination with storing and retrieving data rather than viewing connectivity and connections as the essence of the network? By emphasizing the information or documentation of a work, we de-emphasize the human component of the process. Perhaps within this realm of networked communications art, we can view the human interaction (and thus human memories) as more important than the computer memory.

In his book *Silence Descends* [28] (1997), George Case describes the end of the Information Age from a vantage point five hundred years in the future. He describes a world that has suffered through a series of natural disasters. People have left the virtual behind in order to survive. The virtual does not only exist in the electronic domain of information systems and global networks, but is also evident in the capitalist, consumer-driven society where economy is linked

27. Heidi Grundmann, editor, *Sound Drifting, Introduction*, Vienna: Triton, 2000, p. 3.

28. George Case, *Silence Descends*, Vancouver: Arsenal Pulp Press, 1997.

to purchases and market shares instead of to the well-being and health of a community. George Case's future is not a world without network(s), but it is a world without the virtual trappings that are used as rationale for oppression. In an age of increasing noise and the ever present nostalgia for historical media and new media forms, it is appropriate to look forward and wonder about society's evolution. Will the world be enveloped by a glut of endless storage? Or will the Information Age burnout like so many social and political movements that have come before it. As more and more information is added to the system it becomes impossible to maintain. Links are broken, older software fails to run. The integrity of the data is lost. This broken information becomes less important than the references contained within—the articles and people who, like ghosts, are implied by the vanishing content. In 2005, the Western Front produced *Reverie: noise city*. In the space of a few months, this virtual city went from inception, through rapid growth, and into the realm of historical architecture—a process that takes a real city many decades, often centuries, to complete. As time passes and technology evolves, the city will slowly decompose. The sounds will become incompatible with new software and the design will shift with browser obsolescence. This is a metaphor that the artists discussed in the early phases of the project—the idea that at some point the city would crumble into digital dust. Like many experimental contemporary practices, *Reverie* is ephemeral. Projects of this nature are interventions into a public (yet virtual) space that are intended to make passers-by stop, look, and experience something out of the ordinary before continuing on with their daily activities. These projects are also intended as social networks between collaborators. This particular network space is transcendent; it is the Imaginary Network that is yet to be fully realized. An economy that is poetical[29]...perhaps it will be found five hundred years in the future.

I think in the digital realm, we must acknowledge the pixel. Rather than being ensconced within the stone museum and protected by archivists and restorers, we must know our work is more akin to writing in grains of sand.

—Lori Weidenhammer, The Grim Nymph, diary from ., *devolve into II* ., March 18, 2002.

29. "Poetical Economy" was an idea put forth by Robert Filliou, initially as part of a manifesto: "A problem, the one and only, but massive: money, which creating does not necessarily create. A Principles of Poetical Economy must be written. Write it." (Robert Filliou: *From Political to Poetical Economy*, Vancouver: Morris and Helen Belkin Gallery, 1995, p. 21.)

Bibliography

a. There are many related essays on-line at http://subsol.c3.hu/subsol_2/

b. Annemarie Chandler and Norie Neumark, editors, *Precursors to Art and Activism on the Internet*, Cambridge, Massachusetts: The MIT Press, 2005. Contains many interesting essays on telecommunications and artist-activist networks.

c. Judith Barry, *Public Fantasy*, London: ICA, 1991. This book has little to do with networks and a lot to do with capitalism and shopping. The essay "Casual Imagination" influences .. *devolve into* .. (2000) and its relationship to architecture. Something that I was reading as I was writing this.

ALEX MACKENZIE

"As soon as the film begins,
it is quite clear how it will end,
and who will be rewarded,
punished, or forgotten."

Theodor W. Adorno / Max Horkheimer
Dialectic of Enlightenment

Decadent Resistance:
The Aesthetics of Politics
(and Politics of Aesthetics)
in Vancouver Video
Practice, 1967-The Present

Michael Lithgow

I take as my starting point 1967, the year when portable video became available to artists in Vancouver through the artist collective Intermedia.[1] From the outset, video images were put in service of the margins—avant-garde, feminist, queer, performance, experimental, postcolonial, and community-based. Video art, in its earliest forms, involved complicated responses and resistance to perceived cultural centres—reimaginings of cultural legitimacy. Within these resistant strategic imaginaries, there were (and there are), two dominant approaches: the aesthetic and the politically instrumental, a Tweedle Dee and Tweedle Dum, if you will, of overriding creative intent, both servicing these imaginative practices in different and overlapping ways.[2]

My interest, as an activist and contributor to this collection of writing, is in community-based media practice—when people tell stories to each other using some medium or other, when the tellers and the audience are fluent in shared cultural idioms, and when the telling is largely free of market urges (also characteristics, coincidently, of an oral story-telling tradition[3]). Community-based media usually takes place in a perceived context of political urgency. Community-based video is no exception. The makers most often have a message, and the message is intended to precipitate social and political change.

Vancouver has proven fertile cultural and geographic terrain for community-based video groups of one kind or another—Intermedia, Metro Media, Pumps, Inner City Service Project, Video In, Reelfeelings, Women in Focus, Vancouver Women's Media Collective, downtown eastside media (desmedia), Access to Media Education Society (AMES), Community Media Education Society (CMES), Indigenous Media Arts Group

(IMAGe), Independent Community Television Coop (ICTV), workingTV, AccessTV—among others. The urge to make and share video with instrumental intent is strong in Vancouver, and has always been so.

As an activist, I sometimes thought of video art as decadent, somehow at one remove from the political exigencies that, as activists, we thought we were addressing.[4] Artists were quick to point to the aesthetic weakness and naiveté of much activist video. What I have come to appreciate, and the story I want to tell, is that activist media can also have a decadence, and that video art is often a form of semiotic resistance—that, in fact, it is the combination of these qualities, a decadent kind of resistance, that has made video practice in Vancouver so compelling.

Story #1

One of the last Vancouver-based media projects that I participated in was a collaborative performance called the *Parkade Project*, an intervention which grew to include over twenty participants in a playful illegal trespass. I was one of five creators.[5] Video was used to document the ephemeral dance-based performance.

The idea was simple, the execution more harrowing. We broke into a parkade with performers, props (including grass turf, chairs, tables, lamps, beach balls) and radio gear, to present a mutli-leveled (physically) performance to an audience of about forty across the street on a roof under a tarp in the rain. As the performance proceeded, sounds were transmitted from the parkade to the roof with a micro-radio transmitter.[6] These sounds (which included live music from a violin, French horn, and saxophone trio, sparse dialogue,

1. The first portable video camera was the Sony Portapak, a black and white, reel-to-reel helical scan portable video recorder introduced to the North American market circa 1965.

2. In the nursery rhyme, Tweedle Dee and Tweedle Dum go to battle over a rattle, i.e. they have a meaningless disagreement, but are scared back to their senses by a crow as big as a tar barrel. This paper is my best impression of a crow.

3. Armstrong, J. (2005) "Aboriginal literatures: A distinctive genre within Canadian literatures" in D. Newhouse, C. Voyageur, and D. Beavon (eds.) *Hidden in Plain Sight: Contributions of Aboriginal Peoples to Canadian Identity and Culture* (Toronto: University of Toronto Press).

4. I started in community media at CFRO Vancouver Coop Radio in 1987 as a news programmer and show producer. In the early 1990s, I got involved in community television, and in 1997 helped start ICTV where I was an active director/producer of community television programs and lobbyist. I am currently a director at the Community Media Education Society and CUTV Concordia Student Television.

5. The core group of creators consisted of Jennica Davis, Zac Rothman, Melanie Kuxdorf, Melissa Harendorf and myself.

6. The transmitter was designed by Bobbi Kozinuk, a Vancouver media and performance artist.

etc.) were received and mixed on the rooftop with other pre-recorded sounds. The performance lasted about forty minutes.

The performance itself was extravagant play, a not particularly serious melange of brief acts loosely organized around the theme of urban alienation. Breaking into the parkade and illegally occupying it for the duration of the performance was pure instrumentality. It was a demand that this hulking waste of private liminal space be made public. The demand contained the solution. We made it public, at least for the duration of the performance. This is what I mean by decadent resistance. Where the aesthetics and instrumentality begin and end is delightfully unclear.

Intermedia (created in 1967), occupied three levels of a warehouse on Beatty Street in then derelict Yaletown and was the first artist group in Canada to receive funding for video equipment. In fact, Intermedia was Canada's first artist-run centre.[7] It attracted artists from many disciplines and incubated collaborative exploration, often involving the "new" technology of video. It was a veritable who's who of future cultural luminaries—Jack Shadbolt, Roy Kiyooka, Iain Baxter, Arthur Erickson, Michael Goldberg, David Rimmer, Al Razutis, among others.[8]

What makes Intermedia so central to this story is the seamlessly instrumental and aesthetic approach of its early members to the moving image. Intermedia was as much a part of the socially conscious techno-utopic fervor of the times as it was creative incubator for the avant-garde. One of its stated aims was to intervene in the hegemony of communications systems, and "it's goal," writes Nancy

Shaw, "was to collapse the boundaries between art and everyday life—a utopic plan to improve the quality of life for everyone."[9] Video's earliest practitioners in Vancouver wanted to change the world, in fact, were, by how they were making art. Intermedia was part of a larger movement in the Western art world away from gallery and market constraints. Artists like Robert Filiou and Jochen Gerz in Europe, and the Fluxus artists in North America were moving art out of galleries and into the streets as intervention with the goal of releasing people "from passivity and to empower them to play an active role in determining the nature of the environmental spaces in which they live."[10] It was a desire to intervene creatively in the day-to-day and to change it, to destabilize social and political hegemonies in favour of expanded citizen freedom. Art historian Marion Hohlfeldt suggests that "the artist's descent into real life must be understood as a rejection of the museum and as an act of allegiance to an expanded concept of art: a concept that attempts to eliminate, or at least to question, the traditional gap between work and viewer, art and life."[11] Early video practice at Intermedia was bound in these tensions—a desire for social change, experimental lifestyles and the production of the avant-garde, what artist Sara Diamond calls the "practical aesthetics of early Vancouver video."[12]

The gap, however, between life and art was difficult to close. Competing tensions emerged among the artists and by 1972, despite many early successes, Intermedia collapsed, artists heading in one direction and activists in the other. Tweedle Dee and Tweedle Dum had begun to fight.

It's worth remembering that in October 1970, the federal government invoked the *War Measures Act* in response to the

7. Roy, M. (2001) "Corporeal Returns: Feminism and Phenomenology in Vancouver Video and Performance 1968-1983." Retrieved on August 17, 2004 from www.marinaroy.ca/corporeal_returns.htm.

8. Historical accounts generally fail to mention the names of women among the early members of Intermedia. Their installation "festivals" at the Vancouver Art Gallery included performance-based works by Gathie Falk, Evelyn Roth, Helen Goodwin, and visiting artists such as Ann Halprin, Yvonne Rainer, Deborah Hay, and Lucy Lippard.

9. Shaw, N. (1995) *Cultural Democracy and Institutionalized Difference: Intermedia, Metro Media*" in J. Marchessault (ed.) (1995), (Toronto: YYZ Books).

10. Hohlfeldt, M. (1999) "Caution, Art Corrupts: Reflections on Meaning of Public Spaces in the Work of Jochen Gerz" in *Museion*, Museum of Modern Art, Bolzen/Bolzano, (Ostfildern, Germany: Hatje Cantz Verlag), p. 10.

11. Ibid. p. 10-11.

12. Diamond, S. (1996). "Daring Documents: The Practical Aesthetics of Early Vancouver Video" in P. Gale and L. Steele (eds.) (Toronto: Art Metropole).

13. Shaw 1995:27.

14. Nemtin, B. (1972). "Metro Media and the Community" in *Access* No. 8 Spring 1972 (Ottawa: NFB).

15. The conference was organized by Michael Goldberg (formerly of Intermedia, co-founder of Metro Media, and, later, in 1975, the first officer of Canada Council's Video Programme) and Trish Hardman. Golberg, M. (2000) "Before the Generation Loss" in J. Abbott (ed.) (Vancouver: Video In).

16. Abbott, J. (2000) "Contested relations: Playing Back Video In" in J. Abbott (ed.) (Vancouver: Video In), p. 13.

17. Unpublished interview, June 2006.

18. Directed by Colin Low: (1967), (1967), (1968), (1972).

19. Quarry, W. (1994) (Guelph Ontario: Department of Rural Extension, University of Guelph).

20. (1972) "Challenge for Change Films as Catalyst" in *Access* No. 9 Summer 1972 (Ottawa: NFB) .

21. Shaw 1995.

FLQ crisis in Quebec. The kind of direct state interference with and surveillance of cultural activities that was precipitated by the FLQ crisis, had a singular impact on the times. Video emerged in this context "as the medium of resistance for socially concerned artists."[13] Shortly before Intermedia's demise, a group of politically-minded artists had already broken away to form Metro Media, a more consciously political and community oriented video collective. Metro Media's goals included developing community communications capacity and working with groups such as seniors, immigrants, and welfare recipients to activate their communication goals.[14] Out of this collective came the *Matrix International Video Exchange Conference / Festival* (1973)—in part, a chance to bring video artists from around the world to Vancouver to share their work and ideas, but also in part a response to the *War Measures Act*.[15] One of the overriding goals for the Matrix conference was to create an informal distribution network for video in response to concerns about state and corporate control over existing distribution channels—thus was born the Satellite Video Exchange Society, which later became Video In. That same year also saw the creation of the Western Front, and here we begin to see some of the tensions between the aesthetic and instrumental traditions. Video In, in its early days, was politically driven. "Video Inners," writes filmmaker Jennifer Abbott, "were cultural activists first and foremost...Video In's founding, and in no way humble, project was the redefinition of communications, the democratization of media, and the invention of a present large enough to contain us all."[16] The Western Front, on the other hand, was expressly not political—at least, not in the same way: "The politics were not instrumental politics," explains artist Hank Bull, one of the co-founders of the Western Front, "they were more of an

anthropological or aesthetic politics. The founding mission of the Western Front was, and remains today, to encourage and promote the role of the artist in determining cultural ecology." Is there a politics in that mission?" asks Bull. "It depends on how you want to look at it."[17] Indeed, it certainly does.

Another influential organization, although not based in Vancouver, was the Challenge for Change, the National Film Board's now iconic video and film activist training program also created in 1967. Challenge for Change encouraged the use of video and film by marginalized communities such as prisoners, First Nations groups, the poor, and immigrants to address issues of concern. Challenge for Change sponsored projects across Canada, including British Columbia. The program's influence came in part from the early spectacular successes of some of its projects. In Newfoundland, for instance, a Challenge for Change sponsored video intervention reversed a provincial decision to force the residents of out-port fishing communities on Fogo Island to the Mainland.[18] Not only was the decision reversed, a policy supporting local community development was implemented along with funding to get it off the ground.[19] And in Vancouver, the screening of *Nell & Fred* (1971, Challenge for Change, directed by Richard Todd) was partly responsible for reversing the city's policy disallowing coed emergency shelters, a policy which ensured a chronic shortage of emergency housing for women in the Downtown Eastside.[20] Community-based video was perceived to be a powerful approach to directly effecting social and political change.

Metro Media (who received technical and financial support from Challenge for Change)[21] was perhaps the most overtly

influenced by the program's activist aesthetics, but there were other organizations and other approaches: the Inner-City Service Project (1972) set out to teach members of poor communities and non-profit groups to make video, Reelfeelings (1973) was a women's media collective formed in part to create a women's film and video festival, Pumps (1975) was a feminist film and video collective, as was the Vancouver Women's Media Collective (1978). That so many of these early organizations were feminist, again, speaks to video's early role as an outsider's medium. "Their desire to produce work," writes Sara Diamond, "was based on a developing critique of representation, an urgent need to document a growing radical women's movement, and a history of exclusion from access to the means of production."[22] It was an opportunity for women (and other traditionally marginalized communities) to create in a medium without the burden of overcoming a tradition built on excluding their voices.

In the mid-1970s, community television was introduced across the country. Community television is an approach to the production of programming strongly influenced by the Challenge for Change's practice of making video technology accessible to communities in order for them to tell their own stories. Women in Focus (1974) was created as a feminist production centre tied to local cable access. And at organizations like the Western Front, Video In, and Metro Media, artists produced hundreds of hours of programming for cable television. Shows like *Images from Infinity* (Byron Black), *The Gina Show* (Jon Anderson), *TBATV* were, on the one hand, extravagant avant-garde gestures, and on the other, aggressive incursions into the commodified (mainstream) realm of commercial television. It was art that used the

dominant mode of cultural communication to instrumentally undermine dominant imaginings.

The conservative culture of cable company marketeering eventually began to pressure artists to conform aesthetically and politically to more mainstream tastes. By the late-1980s, most of the artist-run programs had withdrawn, accusing the cable companies of censorship and other transgressions such as selling air time.[23] But echoes of these incursions continued to be heard among Vancouver video practitioners, and continue to be heard today. In 1991, Stan Douglas mounted *Television Spots* and *Monodramas,* advertisement-sized television shorts aired on local late-night television. In 1993, workingTV was created as a community access program to provide local television coverage from a pro-labour perspective (still on the air today). In 1994, the Western Front created WENR-TV, a pirate television station broadcasting in Vancouver's east end, eventually shut down by order of the CRTC.[24] In 1996, the Access to Media Education Society (AMES) was organized to help multi-barriered youth cultivate individual, group, and mass communications skills. In 1997, the Community Media Education Society (CMES) and Independent Community Television Cooperative (ICTV) were created to preserve and protect community access television, the former to lobby at a policy level, the latter to facilitate local access to equipment, production training, and cable distribution. In 1998, the Indigenous Media Arts Group (IMAGe) was formed. IMAGe created the Vancouver Aboriginal Film and Video Festival and provides video training for First Nations youth. In 2000, desmedia formed to engage residents of the Downtown Eastside in collaborative video and visual arts projects. In 2003, East Van Television (EVTV) began broadcasting, a full-on pirate television station

22. Diamond 1996.

23. Abbott, 2000.

24. WENR-TV was created by Vancouver artist Bobbi Kozinuk in the aftermath of a visit to the Western Front by Japanese media theorist and performance artist Tetsuo Kogawa. Kogawa is the originator of theories of polymorphous media and designer of the 2-watt FM radio transmitters which gave rise to the mini-FM movement in Japan in the early 1980s. The TV transmitter for WENR-TV was based on design work by Kogawa. Source: Private communication with Kozinuk, 2004.

broadcasting intermittently in the Commercial Drive area of Vancouver on ("Unplug your cable!") Channel 4. EVTV arrives with the manifest goal of "rising up against unjust media control" and getting members of the audience to make content themselves.[25] The urge to engage the community in the instrumental renegotiation of power relations through the production and distribution of video has always been an important part of the Vancouver video scene.

Story #2

It began, in a sense, in the rubble of what video artists in Vancouver had discovered about cable access, that access really meant negotiating increasingly repugnant cable company demands. In 1997, Rogers Cable (the local cable monopoly in Vancouver at the time) desired simply to deny access. That year, Rogers closed six of about ten neighbourhood production offices. It was a harbinger of more drastic things to come, but at the time, the volunteers at the Vancouver East neighbourhood production office (including myself) were angry and determined to keep making television.

It was a small wonder of public relations and negotiation, but the group persuaded Rogers Cable to donate the television equipment, the office furniture and a year's lease to a soon-to-be-created community organization—and, to continue airing community programming produced through the new group, ICTV, the Independent Community Television Cooperative, was born.

The early years were exciting and idealistic. Long weekly meetings to build policy, discuss programming, fundraise and strategize were bracketed by long hours of video production.

The programming was sometimes charming, funny, and pointed, sometimes hastily assembled, rough, and polemical. There was East Side Story, ICTV's political monthly magazine where people from the community were invited to tell their stories. There were documentaries—a three-part series on the turmoil and state-sponsored violence against students in Burma (Jennifer Suprun), a critical examination of the MAI (Multilateral Agreement on Trade) long before the story broke in mainstream news channels (Kah Jones), coverage of residential school abuses (Greg Dane), coverage of the Gufstasen Lake crisis from First Nations perspectives (Patrice Leslie), coverage of the Ogoni people's endless struggle against Shell Oil in the Nigerian Delta (Sid Tan); there were live hour-long uninterrupted discussions among sex trade workers, First Nations, artists, animal rights activists, bicycle advocates, environmentalists (Patrice Leslie). ICTV also worked with local First Nations groups to provide training to First Nations youth, some of whom went on to successful careers in the field. It was a way for marginalized communities to be heard and seen through the medium of video and television, for knowledge of resistance to be articulated, and social institutions and identities challenged. It was a way for people to play a role in reinscribing the collective imagination.

Of course, there were contradictions. New members arrived with concerns about diversity and gender balance, and these were often swept aside in the scramble to pay rent and make programs. Metro Media faced similar internal tensions. "Despite its best intentions," writes Nancy Shaw about Metro Media, "the centre's multiculturalism was co-opted by the homogenizing and exclusionary tendencies of the official viewpoint. Political resistance was naively seen as

25. EVTV Manifesto. Retrieved from www.sfu.ca/~cbrowne/evtv/manifesto on August 17, 2006.

concretely manifest in rough, immediate, amateur production values... Through its technopopulist mandate, Metro Media attempted to include the excluded, but failed to address its own ideological and representational parameters. It could not situate itself in a larger context, which hampered its awareness of and response to co-optation and complicity."[26] Of course, it wasn't exactly the same at ICTV, but we had our problems and our blind spots, and the spaces close to home that we didn't want challenged. This is what I mean by decadent resistance.

In 2000-2001, ICTV received support from the Canada Council as a media arts organization. In 2002, the Canada Council withdrew support. I asked the program officer at the time why. She said, and this is a close quote, that the Canada Council funds excellence and innovation in the arts, and that ICTV did not fall within either category. Ouch. But, from a certain fragmented point of view, this is merely an observation rather than a criticism. ICTV's mandate was to facilitate access to training and equipment for marginalized groups (and to access production and distribution resources through the local cable company). By definition, the producers were inexperienced. Here, again, we see the tension between two traditions. The instrumentality of a community-based approach, despite its historical roots in video art practice and artists' collectives, was, at least in part, being rejected as a legitimate contribution to the aesthetic tradition and future of video art in Canada.

The policy to shy away from supporting social change oriented video, as it turns out, is also rooted in Vancouver's past. The tension between Tweedle Dee and Tweedle Dum has, in part, been policy driven.

The collapse of Intermedia in 1972 caused ripples at the Canada Council. In its assessment of the collapse, the Council observed "two conflicting directions" of development, one toward "artistic research" and the other toward "social and educational development."[27] The latter was problematic because, in the Council's words, "it questions not only our financial possibilities but our policies and even terms of reference."[28] Certain aspects of artist practice at Intermedia were challenging the Council's perception of who it was and what it did. Kevin Dowler, professor of Media and Culture studies at York University, explains it this way: "The relationship between social action and video has been less of a problem for videomakers than for the Canada Council. The convergence of radical social movements and new technologies in the 1960s resulted in a serious rethinking of both aesthetic practices and the relationship between artist and society. This in turn affected the way in which cultural agencies such as the Canada Council operated. Since its inception, the Canada Council's Art Division has insisted that its only criterion is 'artistic excellence.' Yet once artists themselves began to question traditional definitions of art, what constituted excellence became even less easy to define. As Intermedia itself split apart over these issues, so too did the Council have to struggle to determine its relationship to the increasingly fragmented ideas of what was properly to be called art. This dilemma was of crucial significance, since it determined to a large degree the definition of the Canada Council itself as an agency."[29]

Early video policies at the Council expressly supported a wide diversity of video practices, some of which were tacitly acknowledged as extending "beyond video's artistic possibilities."[30] But the reality of program implementation

26. Shaw 1995:33.

27. "Intermedia Project Grant Application," *Arts Agenda* 118 (27-28 Sept. 1971, p. 166) as quoted in Dowler, K. (1995) "Institutional aesthetics and the politics of video at the Canada Council" in J. Marchessault (ed.) (1995). (Toronto: YYZ Books). p. 36.

28. Ibid.

29. Ibid.

30. "Canada Council, Position Paper on Film and Video." Nov. 1974 in *Policy Agenda* Vol. 216 (9-11 Dec. 1974) p. 126 as quoted in Dowler 1995.

was narrower and tended to "exclude all activities except those that were artistic or aesthetic in nature—which remained, nevertheless, undefined".[31] Political video and video activism were being calved away from an institutional understanding of what should be considered "video art".

Coincident with the changes to funding policies, rifts began to open between artist groups and practitioners. According to Bull, at the Western Front, there was a strong sense that what they were making was art, not politics, even though some of their early gestures (like running a giant peanut for mayor in 1974) directly engaged political processes.[32] The interventions were semiotic rather than demands for instrumental outcomes. Mr. Peanut received votes, but the goal was never to win the mayor's seat; rather, the goal was to destabilize hegemonic notions of democracy, electoral politics, and political identities.

Video artists interested in social change were also developing their own exclusive approach to the medium, in part, a conscious rejection of art aesthetics. At *Trajectories '73*, a large exhibition of Canadian art mounted in Paris, video figured prominently. At the exhibition, the artists (who were mostly from Video In and Videographe[33]) offered workshops teaching people how to use portable video for political ends. They were criticized by local reviewers as sociological, young, and naïve.[34] Indeed, for many video activists in Canada, community participation in the production process became synonymous with an ethical rejection of style in favour of unadorned speech.[35] The traditions were being driven apart by growing differences between artists and by bureaucratic policy shifts that had more to do with institutional turf wars than the artists the policies were intended to support.

There is a broader context for these divisions and tensions. The rise of identity politics and postcolonialism in the Western art world in the late 1980s and 1990s touches on similar themes at issue. "The medium of video," writes Emily Carr Institute of Art and Design director Ron Burnett, "becomes a place of work in which the self is created and recreated—life is art. In this sense, the socially constructed self gains the ability to rebuild, and this can be done privately or publicly."[36] Reinscribing who we are challenges—or certainly can challenge—the relations of power that produce and reproduce existing social and political norms. For example, in the dominant story, we might see a junky and a loser; in a reinscribed story, we might see an activist demanding policy changes in the midst of a medical crisis.[37] Knowledge—the production of certain kinds of knowledge— can destabilize the production of hegemony. It is a kind of resistance to monopolies over the production of legitimacy.

Video artists in Vancouver have been reimagining gender, class, race, ethnicity, sexuality, nationality from the outset. They have been reimagining what it means to be human in opposition to imposed and more constrained and destructive identities (they hardly need be named: junkie, Indian, fag, the lazy poor, etc.) Video was an outsider's medium, grabbed early by marginalized communities and difficult to commodify. Despite appearances of early acceptance at sites of institutional legitimacy (the Vancouver Art Gallery allowed unprecedented access to exhibition space for video artists from Intermedia), the thrill wore off and old patterns of centre/margins and exclusion were re-established, sometimes in dramatic fashion. The 1984 cancellation of *Confused: Sexual Views,* an exhibition of video work by Paul Wong, Gary Bourgeois, Gina Daniels, and Jeanette Reinhardt

31. Dowler 1995:42.

32. Unpublished interview, June 2006.

33. Videographe is located in Montreal.

34. Shaw 1995.

35. Marchessault, J. (1995) "Amateur Video and Challenge for Change" in J. Marchessault (ed.), (Toronto: YYZ Books).

36. Burnett, R. (1995) "Video Space / Video Time: The Electric Image and Portable Video" in J. Marchessault (ed.), (Toronto: YYZ Books).

37. A reference to the story told in Vancouver-based documentary maker Nettie Wild's *FIX: The Story of an Addicted City* (2002).

commissioned by the VAG, is one example. The exhibition was cancelled at the last minute because it had "no aesthetic merit, could not be placed in the context of visual art" and was therefore inappropriate.[38] Fast forward to the 1993 Whitney Biennial (a major showing of contemporary American artists at the Whitney Museum of American Art in New York), and we find a similarly controversial Tweedle Dee and Tweedle Dum clash that exemplifies the continuing tension between aesthetic and instrumental practice. At the Whitney, what caused the uproar was a curatorial choice to privilege voices traditionally excluded (i.e. non-white) from Western centres of cultural legitimacy in an apparent attempt to expand legitimacy to include the direct renegotiation of power through artistic practice. Much of the work was directly engaged with race, sexuality, and gender. The exhibition was condemned on many fronts (not the least interesting of which was as a kind of institutional shell game, a white-washing of exclusionary histories within the art world). But the more prevailing criticism and the one germane to my Vancouver story, was that the artwork in the exhibition sacrificed aesthetics in favour of collective political self-interest.[39] In other words, that the artists had "displayed a disregard for (or ignorance of) the dominant and existing critical and historical dialogues, and that this view suggested that the work exhibited operated outside the accepted critical and historical parameters" by including "intellectual debates viewed as extraneous to the materiality of art, discourses such as queer theory, postcolonial studies, and critical race theory."[40] They might just as well have written that these voices offered neither excellence nor innovation in the arts.

Even the label "identity politics" suggests that there is a kind of art that is not engaged in the production and maintenance of identity. "Using the markers 'social' or 'activist'," writes art historians Derek Murray and Soraya Murray, "to describe these artistic and intellectual efforts is misleading, in that they place minority engagements in an inherently peripheral position."[41] The magical realm where identities are not questioned, where social and activist tendencies are absent, is a fictive, normative position where the identity being constructed, perhaps for obvious reasons, is bashful. It is the identity of power.

Vancouver video practice, then and now, inhabits a similar problematic space. It is, and has been, an at times, clumsy, and at other times, deft and elegant attempt to encourage, facilitate, even broker the reimagining of self by citizens, by the people who live in the communities that make up the spaces where we live. Mr. Peanut (the giant peanut candidate in the 1974 mayoral election) is one example. Indigenous Media Arts Group is another. In either case, it is the clever and complicated collaboration of community-based instrumental intentions and aesthetic sophistication that makes Vancouver practice what it is, and to my mind, so creatively fertile and compelling. Even if, as I've suggested, cultural funding agencies sometimes don't get it, and the artists they want to support are challenging *their* identities, just as they are challenging and destabilizing existing social and political relationships. Even if artist groups don't get it, and the art they produce, because of an unwillingness to witness their own role in the production of hegemony, slips into decadent obscurity. Even if video activists don't get it, and their indifference to aesthetic discourse limits complexity, readability, and self-reflexive gestures that might reveal replications of hegemony in their practice. There are some that do get it, and these, I suggest, are the legacy

38. Daniel, B. (1984) "The Balance of Convenience" in Parallelogram 9, 5 as quoted in Abbott, 2000.

39. Wright, C. (1998) "The Mythology of Difference: Vulgar Identity Politics at the Whitney" in G. Kester (ed.) (Durham: Duke University Press).

40. Murray, Derek Conrad, Murray, Soraya (2006). "Uneasy Bedfellows: Canonical Art Theory and the Politics of Identity" in Vol. 65(1).

41. Ibid.

of Vancouver's unique history. The best of Vancouver video practice, be it the stuff of high aestheticism, or the stuff of street protest, has a way of pinching us in both places—art and activism—then fucking off, leaving us with an ambiguity of images, faces, sounds, and words. We can love and hate it, any which way we like. But we can't ignore it.

Story #3

In the Fall of 2004, I curated a Canada Council sponsored video art exhibition called *The Art of Fact* on behalf of ICTV, in partnership with Video In. The exhibition aired on the community channel. It was an attempt to suggest that the separation of Tweedle Dee and Tweedle Dum was artificial, or at least to explore the tension and see if there really was a fence, one side of which we find the artists, and on the other the activists. The video work came from the Video Out archives, some of which dated back to the mid-70s. Work from artists like Dana Claxton (*The People Dance*), Jayce Salloum (*untitled part 3b: as if beauty never ends*) Randy Lee Cutler (*Transportation*) and Emma Howes (*Kitchen Dances, Laundry Room*) was juxtaposed against the more recognizably narrative work of Nitanis Desjarlais (*Warriors on the Water*), Richard Ward (*No Masters Yet*), and W G Burnham (*Gender Line*), among others. The issues raised ranged from First Nations identity, gender politics, and the Palestine-Israeli conflict, to a violent dispute over fisheries between a local First Nation and the Department of Fisheries and Oceans, surveillance cameras in the Downtown Eastside, cancer treatment, and the history of video art in Vancouver. The exibition revealed two things to me: in a striking way, witnessing video art in the flow of commercial television highlighted the profound creative failure of commercial television to address the potential of the medium itself; and,

perhaps unsurprisingly, that it was next to impossible to make clear distinctions between what was activist and what was art.

On one hand, the exhibition demonstrated innovative, playful, and challenging semiotic and aesthetic explorations of the medium. On the other, it was beamed into approximately 60,000 living rooms in the Lower Mainland the estimated viewership of the community channel at any given time—using one of the most powerful and commodified cultural tools in our society. And what was being beamed were challenging discourses on controversial issues of public concern. It demonstrated to me the power of video when it *inhabits* the tension between art and activism rather than favouring one or the other. Which is where, I think, all this began, with Tweedle Dee and Tweedle Dum as nursery rhyme characters rather than an awkward conceit for a tradition whose strength lies, not in the artificial division of politics and aesthetics, but in their beguiling and, much to our pleasure and reward, sustained unity.

YUNLAM LI

Swimming Upstream/
Fragments from a
Conversation

Jayce Salloum & T'Uty'Tanat-Cease Wyss

70

...Cease Wyss: My traditional name is T'uy'tanat and I'm from the Squamish nation, from my grandfather's side. From my grandmother's side we're Stalo, Stalo being right in the heart of Coast Salish territory, going towards the east, Yale being the tip of the territory. After that it becomes Interior Salish.

Jayce Salloum: That's where I'm from, nSyilx'cen land. I wanted to invite you to collaborate with me on this text as in my videotapes, which I view as collaborations when they involve individuals as subjects. I've been working closer to home since I moved to Vancouver. Before that, political situations often sent me elsewhere to videotape and then I would return home to edit, wherever home happened to be—Toronto, San Diego, New York. I typically find myself in the position of being the one to ask unspoken questions, things never talked about. In video I utilize various modes of articulation, visualization, and representation. There is some work where the formalist concerns take precedence but the material is always tied to a socio-political situation, or somebody's life. My early tapes were transgressive, deconstructionist pieces using television footage, attempting to subvert the dominant media's representations, looking at their influence on our lives and the construction of our psyches. Later, when taping people talking about their lives, I felt more of a responsibility to the person speaking—not like using found footage where you can just slice and dice. In taping conversations with people living in Lebanon, Palestine, Cuba, and the former Yugoslavia, the look of my work changed. When I moved to Vancouver I became more involved in my neighbourhood, the Downtown Eastside. I set up the desmedia collective to highlight local production and create continuity in facilitating drop-in video/painting

workshops. My attempts to produce appropriate modes of production, locally and internationally, stem from placing my work within a politics of affinity. I'm interested in the possibilities (and impossibilities) of videomaking and the responsibility of representation/production. Like, are we responsible to the subjects or the tape object itself?

CW: I've had almost the opposite experience, where I started from a place of documenting people. Once my mother looked at me and said, "You've got to get into video, this is what you've got to do. You've got to help me, I need interviews with elders." And I'm like, "Okay, I don't know if I'm technical," and I laugh now because I really own that part of my knowledge. At that point it was more about not having the proper self-esteem but knowing that there was something that intrigued me about the process. My first project was documenting elders for an archive with a focus on looking at their land claims. There was this immediate need for an approach to caring for the subject. This focus has become more distant now, so that I find myself looking increasingly at found footage, and exploring my own storytelling.

JS: Which elders were you taping?

CW: From the Katzie nation, a tribe located at Port Moody and Port Coquitlam, almost in Haney. Part of their territory extends north over the Pitt River. They border with the Squamish people over the mountains of Garibaldi. Our territories meet there. My mother knows a lot of families in all the different tribes, as the Coast Salish stick to each others' communities, traditionally marrying within Coast Salish nations. Many tribes, different families, but similar protocols and culture.

JS: Was videotaping a way of getting more engaged with your culture?

CW: Absolutely. The elders spoke about areas that I grew up around but never quite fathomed because of living in two worlds. In the white world people have a nuclear family, then first and second cousins and stuff. As Coast Salish we think about all of our family, second, third, fourth, fifth cousins. It's very strong how we see the world in relation to each other as family. I grew up traveling up and down the river with my mom, going to these tiny reserves to get fish or berries, to have tea with grannies I didn't know very well. It was always about elderly people embracing us as children and knowing that they're our family. I wasn't always sure how they were family but later when you go back and do an activity it becomes clearer. Documenting elders re-awoke childhood memories of relations and the village sites they spoke of. It came at a very significant time, helping me to realize that you don't have to be doing something traditional to reconnect with what your spirit is. I learned that this technology is a gift and it's something that helps, especially somebody who's been pulled away from something.

JS: So you found that video was a way for you to ask questions that you weren't able to easily ask before?

CW: Yes, it allowed me to create the questions for the answers I was seeking. I'm an herbalist. As a child my father took me out and showed me plants; but he's not native, he's Swiss. As a kid I didn't know the difference, I saw him culturally and that he lived off the land and had a connection with the plants, animals, and even the rocks. I had the same connection with my grandmother who was one of the last people from her

tribe to weave cedar root baskets. She gathered medicine and materials, everything. She never drew her designs, they came from her mind and heart. That was the spirit that drove me. If I only ever pick one plant for the rest of my life, I'm still doing something culturally significant. It's a political statement to go to the land and ask for help instead of going to the drugstore.

JS: Is there a relationship between that process and your video making?

CW: I'll go out with an idea of what to look for, gathering medicines for a specific ailment, but I may come back with an altogether different plant that I didn't expect to find. Gathering medicines is a social and political activity, and simply a need. I could make this a difficult thing or I could be easy on myself and have a relationship to the earth and accept what the teachings are to me. With video, I'll start off with an inner idea and it completely transforms in the process, it comes from a source where it's meant to come from. If one method isn't working, I'm not going to fight it. It's the ideas that involve people that I'm really going to learn from, and those might be harder or longer projects. It's about the community building that happens. It's not about taking, but reciprocity. That's something Coast Salish culture is built on, giving and receiving. Whatever I'm doing has the infusion of those elements. By picking teas, I'm trying to help resolve health issues; while by making videotapes, I'm trying to help resolve the way aboriginal people are seen. My current videotape looks at what foods aboriginal people ate traditionally and what they eat now. Whether we're gathering berries in the bog or in Safeway, in East Van there's going to be half a dozen aboriginals in the store with you, collecting

and gathering, carrots, corn chips, berries...they're actually eating a lot of indigenous foods, it's still relevant whether you're eating fresh or frozen berries. You're eating food that your body craves and that will help sustain you, and they're both a connection to the earth.

JS: In making my videotape with the Syilx'cen Nation (*untitled part 4: terra incognita*), Roxanne (Lindley) spoke about the field trips they take kids on from the schools in Kelowna. They discuss how all cultures had a knowledge of the land and indigenous plants they used for medicines and food. They pull things from German and Russian history etc. about the plants that were used. They all had these connections but people moved away from the land, got distanced from it and stopped having that connection, stopped having that respect...

CW: Yes, stopped believing in what the land is giving you.

JS: Occasionally critics try to confine my identity, stating that I shouldn't be working with certain people(s), asking what does that have to do with being Canadian or an invisible minority or whatever you are at that moment, especially when I've been working within current politics. There's this attempt by many to reduce one's identity into something they can control. I resist that, and have always seen an affinity with struggles of self-determination and other processes of self-representation. Part of my responsibility as a producer is to recognize commonalities in others and to make appropriate representations and representations appropriate for just being here...

CW: If I'm interviewing an elder and bring up things that are too difficult for them, I'm not going to push it. It's abusive and a misuse of video tools. It takes advantage and I already know as an aboriginal woman that there have been too many horrid media stereotypes we've had to kill ourselves and that we've had to work to change and create a stronger, better image. I'm going to treat everybody I'm taping with respect; however, going from interviewing an elder who's had to live a life of poverty and oppression, to the point of repression that they can't get out of, and then turning around and interviewing a priest, I still respect that priest as a human, but I wouldn't be so gentle with my questioning. A lot of aboriginal people feel a rage for the church, but the priest in front of you is your generation, or maybe your parents'. You're looking at someone who's a systemic result of this problem and is as much, in some cases, a victim of where things ended up, as are you or your relatives. If I intend to shoot in my longhouse I talk to those doing the ceremony and ask what I can and cannot document. To use a traditional song, I try to find the oldest member of the family. For instance, Chief Dan George has a number of children that are my parents' age or older, so I go to the oldest member, Bob George, and I ask him, can I use your father's song and share it in this story, bringing gifts and acknowledging, but spending time, you know, sitting and visiting, for not ten minutes, not even looking at the clock, however long they want me in their house. They want me there three hours, I'm there three hours. I'll meet Bob, his wife, their children, grandchildren, great-grandchildren, all who pass through the house. The visit is kind of unlimited, it's what happens. If they don't give me their permission, then it is what it is, I'm not going to use it just because I spent the time there. It's still worth my energy and commitment. I know my responsibility culturally, socially, and politically is to take that time. I don't put a quantitative value on it. If they're not happy

72

with the work that I'm doing then I have to go and work on myself and find a way to change my way of thinking and understand where they're coming from.

JS: It seems for artists at all levels it's not just enough to have the motivation and the empathy, you have to have an experiential knowledge base and know the protocol to be able to carry the material into the world, whether it's a story, image, name, text, or title. When I work with people it's a mapping out of things, such as enunciation and positionality... how people tell their stories besides the stories that are told, and the development of an intimacy, the connection you can have to that person as an individual, and how that individual is related to a larger community and how it ripples over to other audiences. All of my work has been about challenging the viewer to re-think their perceptions and received representations, providing an opening for them to reconsider situations. I don't think you can ever understand another subject fully, but you can have a more complex relationship than just the reductive, essentialist patterns where one tries to condense/consume histories, events, conflicts, and lives, as we go about our daily business...

CW: As aboriginal people we've been forced to accept the Hollywood Indian and everything in the newspapers about us stealing the resources, we're always represented as thieves and whores, we're just trash, we're red trash, and it's like, okay, really: we're dirty, filthy? But everything I've grown up with has been the opposite, where it's been such respectful things. I try to make my work empowering for aboriginal audiences. It's about gathering soapberries, eating pemmican, making your first drum and feeling that rawhide, what people use to make many things with. If it's a non-native

person looking at my work, they may not imagine that some Indians drive their pickup to an office job, but as soon as the season is open they're right down on the river to fish for their village, their people, and they're doing this stuff that to them is like survival, it's something that if they don't do it, they don't feel good. If only two people, a native and a non-native person can take positive stuff, and deconstruct one negative element of what they were thinking before, I'm going to feel empowered as a filmmaker. Native people may live off the land whether they have Nikes or moccasins on, or bare feet. There's just as much internal racism in native people today because of all the negative media stereotypes we've been forced to digest. My videowork could be seen as a big cup of healing tea, getting rid of all the crap you didn't need to think about Indian people. I don't think I'm going to change the world, but one videotape, one cup of tea at a time, I'll do what I can.

JS: Is there any relationship between your work and traditional art practices besides protocol?

CW: There's a direct relationship to past ways. I often wonder what I would have done if I lived two hundred years ago, pre-contact? And I've imagined that my life is not that much different than what it is now because I live very frugally and I've been in a hard place of transition working towards understanding my relationship to the earth. It isn't a contradiction that I'm running around with video equipment. I'm taking a modernist medium but approaching it traditionally. I'm a storyteller and I'm determined that the drive comes from an old place that has lived through a lot, not just in this life but in other lives. I am very driven by tradition but I'm trying not to hang onto everything

traditional. Living in an apartment or a house you can have a sense of disconnectedness as soon as you walk in the door. I want to feel good in the two worlds I'm living in, and at times want the two worlds to live within me.

JS: One can never be outside the history of film completely because it's a history of production. Early forms of media representation—engraving, photography, followed by film—were always at the service of colonization in documenting and in designing policies of conquest and occupation. How does your work re-appropriate the dominant voice or language in regards to history and ethnography's relationship to contact and displacement?

CW: With my work I confront the process of decolonizing the minds of aboriginal people, and non-aboriginal people. Like, looking at Edward S. Curtis' (1868-1952) very serious well-intentioned portraits of aboriginal people, which for the technology of the day you had to have these stern faces because of the amount of time the film took to expose. His purpose was to photograph all the native people before we disappeared, but we didn't. And like you said, we just keep coming back, we keep re-emerging. Indigenous people worldwide share that throughout the history of media. They're incredible photos, but there's this darkness in each of them. This is the image he wanted to cast on the world. My approach isn't to save a token of information because I feel it will disappear. I know it's not going to disappear, I know the strength of oral history and that culture is kept together by more than what we wear. I don't have regalia, but I feel strong about who I am. I feel like a warrior at times, and at other times I feel weak. Looking at the writings of Franz Boas and other archaeologists, ethnobotanists, everything

in that history, my early roots were in anthropology but I always struggled with looking at things in boxes, and the idea of unearthing things to put them in a glass case never to be touched again...to live and speak in that dialogue became so foreign the more I learned about it. It became so disconnected. Putting sacred objects in a museum will only help people that are not from that nation, but if I bring those objects to a family's home and they in turn re-introduced them into their ceremonies, as a people we would be more empowered. Curtis' pictures, as beautiful as they are, have not served to help aboriginal people in any way. It's only by inspiring to change those things that it's helped us.

JS: How can you make meaningful work in relation to the way everything has been standardized, dumbed down by television, and the cult of celebrity reigns supreme, while only a few dominant corporations in the world have taken over all the mainstream information and entertainment sources? How do you project yourself into or around those paradigms?

CW: We've seen about thirty or forty years of aboriginal people in this country starting to create their own works, but predominantly it's been other people's perceptions of us created by the NFB, CBC, and PBS. So you become a trailblazer, whether you're somebody like me that's been working in media arts for over a decade or somebody that's just come out of a short film program. We ask "How does my story even get heard by anybody?" I always defy the standards that are set for me because that's just decades of repression. There are so many things we have to compete with. I have to battle the overall aboriginal stereotype as I have for most of my life. I use it as my strength. It's like getting up and

brushing my teeth, if I forget for a week it's only going to come down hard on me. I'm always going to be questioned about my motives. I'm questioned about my subjects and my systems, whether I followed protocols or not. The easy part is learning to use this technology, the difficult part is going out and feeling good about using it, because people are going to criticize everything you do. We have to question each other. It's how we grow as a community, whether you're native or non-native. If we don't know how to account for what we're putting out there, if we don't have an answer to the questions people are asking of us, then we have to ask ourselves why are we even making it. It's not just a responsibility to the community, culture, politics, and the social issues of the time. It's about ourselves and what we're producing. We become responsible. With anything we do, it has a purpose.

JS: There is a context and culturalization that an individual's subjectivities are being constructed from. We are always part of a larger body. If you're coming from a community where there's more of a shared history—especially where histories are passed on orally—there's a shared memory, a collective memory. Like the history of the Palestinians sharing a common dispossession of a home/land, peaking in 1948, but commencing before and repeating afterwards to the present. At some point the history or the people may separate, going to refugee camps, or they might have come to the west, or gone to another country and been able to live a relatively normal life somewhere else, but they share that loss and history carried with them. It's something to do with survival. Part of native history is contact, the genocides, the dispossession of the land, the creation of the reservation system, and the residential schools, there's a collective history. Whether you choose to work with it is one thing

but it's still part of you, it takes all those generations to live through it. Around here there are layers and layers of issues that come up because of that history. It's still being processed, or being blocked... Is there a sense of collective memory in your working process, or is it important in how it influences you and is manifested?

CW: Working with youth from the Tsleil-Waututh Nation I asked them each to gather one story from their parents or grandparents about their experience in residential school. The stories were re-enacted by the youth in their film, beginning when the boys are out spray-painting the church, get caught, and are told they have to paint over it. The girls come along and start making fun of them, and as they're standing around they hear a noise in the church, and they enter to see what's going on. Inside, each of them touches something and gets transported back in time. Other stories follow. One girl who wanted to run away, she shared this with other girls. She imagined she saw an apple in the church and picked it up and fainted and woke up in her grandmother's body, in her memory, and she went through everything her grandmother lived through. They were ad-libbing when they came out of the church. It was like their grandparents were speaking through them, they literally made a collective memory film. The project brought out stories that none of them knew and were severed from. One boy's account was about being strapped by a priest at the front of the church. Intense imagery that brought out heavy memories for people at the screening—pushing back or moving forward... It wasn't "let's just stay here and hurt." For most of that nation it was about watching it together and watching their youth who never talked about residential school before being able to re-enact scenes with such fierceness that it was so real

for them. Most of the kids had a lot of issues with each other when they started. At the end of two months they realized they really loved each other, and most of them were related but never spent time together. It showed me again how the power of media is in its ability to bring people together, like a weaving—it all comes together and produces something beyond itself...How has living in Vancouver influenced your work?

JS: It's difficult to separate that out because I've worked in so many different environments. During the rainy season I'll spend days on end working without leaving my loft. Making my work has always been a way to internalize and to return, to focus myself and process things. It's the only real continuum in my life. If everything else fails, I know I'll always be making things, whether it's video or driftwood sculpture, it doesn't make much difference. But I think the sense of space here, and the sensual, tangible, tactile nature of the air and the environment has become important for me. Tactility in video is somewhat elusive, it's hard but necessary to find that sensuality, so I've always done these wall pieces, collage-type things and drawing on photos that take me outside of my head. It's like planting, having this little dried-out garden. There were other plants, they died of neglect, but these ferns blew in from the park. The bamboo is exotic but the Buddleia and the Echinacea are indigenous too.

YOU ARE NOT QUALIFIED TO MORALIZE

YOU ARE NOT FREE TO PURSUE GLAMOUR

IT IS RIDICULOUS TO ADVERTIZE YOUR SUBJECT POSITION

IF YOU MAKE ART THAT IS ACCESSIBLE PEOPLE WILL SAY YOU ARE A DULLARD

WHO DO YOU THINK YOU ARE TO ENGAGE IN POLITICAL INTERVENTIONS?

NOBODY WANTS TO HEAR HOW ROUGH YOU HAVE IT.

YOU ARE ADDICTED TO YOUR SUBORDINATION. FIRST CAUSE IT WAS THRILLING. NOW CAUSE YOU THINK IT MAKES YOU AGOOD PERSON.

YOU LET YOUR INSECURITY GET THE BETTER OF YOU.

THERE IS NO SUCH THING AS A CLEAR MIND.
THE ONLY THING THAT MATTERS IS CONFIDENCE.
ALL YOUR FRIENDS ARE EITHER MORE DECENT OR MORE SUCCESSFUL THAN YOU. NONE ARE BOTH.

IT ALL BOILS DOWN TO THE SAME THING: MOOD. IT S THE ONLY ECONOMY THAT TRAVELS.

COOPER BATTERSBY & EMILY VEY DUKE

DAVID CROMPTON & ANDREW HERFST

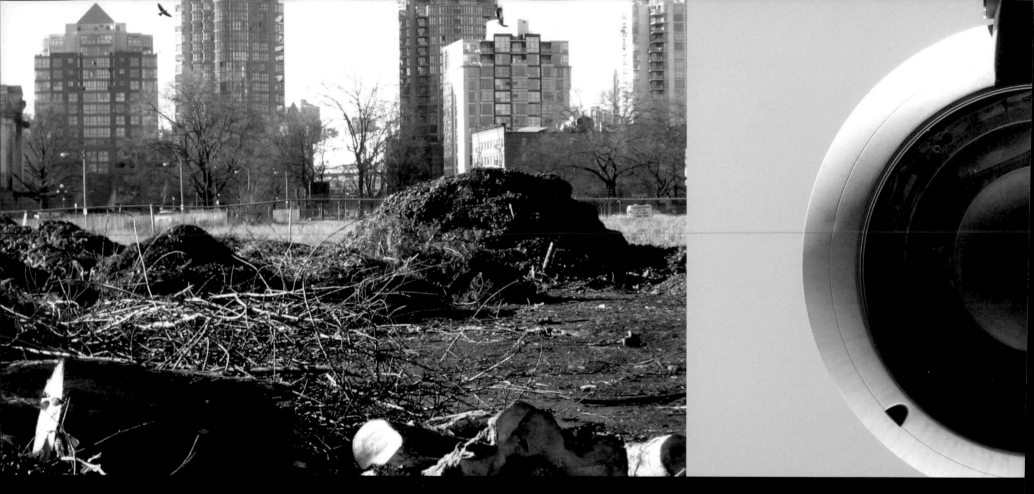

Late in 1984 I found a strange postcard which featured a view of Vancouver which simply did not exist. The city had been framed so as to foreground two large-scale government projects—the then relatively new domed stadium and, represented by an artist sketch, the as yet uncompleted SkyTrain system (which, as the description on the back noted, "was on time and on budget"). But the train depicted was running along a route that did not line up with the actual route. As well, the mountain backdrop had somehow shifted from its actual geographic location to a point several kilometres to the West. The elements, however—domed stadium, elevated transit, mountain setting—fell together photogenically in a frame and

so the practitioneers of image management had here displayed a Conceptual Vancouver, a Utopian City of the Future.

And so I became interested in this Conceptual Vancouver, and in its abstracted idealism, and in the ways by which the problematic political realities of allocation—where does the public money go and what does it do?—were neatly airbrushed away much as SkyTrain was airbrushed in.

Historically, Conceptual Vancouver has in large measure found fruition via large-scale publicly-funded circuses, which appear

every few decades, sold to the public as a vital element in putting the city "on the map", as if it wasn't there (or here) already. Commonwealth Games 1954. Expo 86. Winter Olympics 2010. All presented as the key to the future, and providing large infrastructural legacies while, less noted, changing the facts on the ground in the more mundane realities such as land zoning etc.

Once involved in documenting the Conceptual Vancouver, I noticed it gradually became a process of returning—returning to themes, returning to areas, returning to frames. Anticipating the passage of time became a part of this process, anticipating the future in

VANCOUVER
City of the Future

FUTURE CITY

the present, or the past in the future—then later being informed by and framing the past in the present; locating frames in anticipation of the scene ten years down the line. This at times would situate me in an odd place, not exactly a deja vu, but disorienting nonetheless and something I could not quite explain.

Then, in 2006, news outlets noted the findings published in the academic journal Cognitive Science relating to the Aymara peoples of the Andean highlands. The Aymara have a sense of time, expressed linguistically, which is the reverse of a common forward time axis. That is, they speak of a past that is ahead of them

(which has been seen and is thus knowable, seeable) and of a future that is behind them (not yet seen, or experienced and thus out of sight). I thought the Aymara must have spent time in Vancouver, and that in Vancouver we also have a reversal, expressed linguistically, when we speak of the future but mean the past. The city keeps returning to its past concepts of the future.

Cycling north on the Cambie bridge in July 2006, I was stunned to suddenly see a close representation of a frame from my first Conceptual Vancouver project, a shot taken in December 1985.

ings rose above the bridge deck railings and cut across the black silhouette of the North Shore mountains. Then it was an Expo Pavilion, now it was another condominium project of the many that have proved to be the true legacy of Expo 86. Still, visually—and Conceptual Vancouver is visual—twenty years later it seemed I was facing forward to the past. And, as I stood there, behind me and south across False Creek, earth was being moved for the Olympic Village of 2010.

From notebooks found in a Single Room Occupancy

The following text and images come from journals and notebooks found in a small suitcase. I heard a rumour that when occupants of rooms die or skip on their bill, their belongings are held for a period. In many cases, the belongings and the identity of their owners become separated. With some cajoling and bribery, I was allowed to satisfy my curiosity by looking through certain suitcases and boxes. The Niagara Hotel was being renovated and so I felt it was important that some act of witnessing be done, before business dictates kicked the ruddy glory out of the place. I knew it as a strip bar and live music venue. It was a place where famous writers drank. I think Malcolm Lowry took Dylan Thomas there.

I could be wrong.

WARREN ARCAND

1.1 Water thoughts

1.2 The indifference of wetness—my utter dependence on water—if
I am nothing without water, are we not water too in our own way?
Then can we not have some of the powers of water? well. We do—
but we can't go quite as far as she do

1.3 Water images—'makes us a residence'

1.4 Why isn't water a god?

1.5 Certain persistent images of wetness as they appear across
cultures testify to the dialogue being had with water—sporadic,
unfinished, inconclusive but compelling, full, meaningful—conversant
—still, always undone

2.4 Weather and houses—play of tools and weather—damp—wet—mobility—wetness makes a certain idea of motion—motion unattached from machines—motion not of animals nor machines—motion not quite of weather—a motion that makes a residence of bodies—Most machines

2.5 On one hand is the text—boundary regions—around art that is a part of the art as an aspect—an aroma—kind of a misting—then—being before it—the mist of the falls—if not for the mountain—but no—it's about the falls—it's not the mountain, it's the falls

2.6 What's meant by "makes a residence"?

2.1 Vagrant heart of the place

2.2 There's an idea Derrida has about architecture of a house, place, residence is a place with a path going to and from it and with paths going through it—without these features, it is not a place—and it's a way of thinking about architecture—it's also then what water does—to us—it's what Vancouver does to me—And it's what she does to me—see, it all ties together

2.3 So is a path only ever to be understood as a communication between two or more places—isn't there something of its own there? Well, sure man

3.1 I have a machine in mind—it will make me rich—then I can leave this place and be gone forever after

3.2 I think of my lapsaway. It helps to make an help image to understand what's happening to me

3.3 Lapsaway object with photos and diagrams

3.4 Maybe 'Lapsaway": a movement towards a resolution of an emotional situation occasioned by the imposition of multiple stressors arrived at as a strategy for maintaining a measure of personality cohesion

3.5 The machine was designed to keep laptops from sliding off people's legs—it was made to address an anxiety—a specific anxiety—but I'm finding other uses for it—the machine is a medium—and is metonymy for media arts—it helps me see into the ways of my practice as it helps me see into the reasons I'm living in this hotel—Maybe she'll like the answers enough that she'll take it as evidence that I'm worth it

3.6 The machine is modeling and creation

3.7 The machine presented as solution (resolution?) to a crisis

3.8 We hold that: thinking about and describing the lapsaway may reveal something particular and peculiar about making motion pictures in this part of the world

4.1 "We don't know how free we are"

4.2 I came back from a conference in Libya—Moamar gave me an embroidered pillow and recognized us and our struggle as Aboriginal people—it would mean more from the UN security council—but every little bit helps, I suppose—I wonder what it's stuffed with?

4.3 Libya—being back in Vancouver—it's like living in a bubble—it doesn't feel real—it's ripe for the taking

5.1 In the movies. When characters are wet it's an image of being tangled in events beyond their control (*Bridges of Madison County, Bladerunner, Apocalypse Now*)

5.2 Wetness (blood, tears, cum which includes body fluids) is a dramatic high point, where the content of the drama overbrims the players—also in that, the wetness signifies truth or honesty or material reality—it serves as a kind of proof—it enters the scene bearing that kind of authority

5.3 That would be the positive—the negative would be where the filmmaker needs to rely on the aqueous content of ancient images to communicate the thing they couldn't introduce, these mighty themes, they couldn't get on screen all by themselves, by the power of the edit and the magic of 1+1=n1

5.4 Also it's a stripping or reaming of what the player is—meaning how they are represented as self-representing—they are emptied out and made a residence—they aren't self-representing or self-evident anymore—they become empty as doorways and paths—they become structures of departure and arrival—and as scenes for departure and arrival—when they are most expected, they make way for water to represent the transformation they undergo—but they were never anything substantial—just the idea of being someone—and their truest selves are revealed as being residence, not resident

5.5 That moment when wetness arrives, we all step back—even when the players are affected, there's a stepping back

5.6 Movie stills—moonlight on water

6.1 A little matter of psychological realism

6.2 Proposal: there's something about the city—a wet spot on the sheets—I elect to lie in the wet spot

6.3 It's humiliating—it really is—she doesn't know what she does to me—that's why I don't mind the rain so much—this hotel room—it's a good reflection—SRO

6.4 It's good to have things to occupy myself—lots of smoking lots of drinking—it's a kind of work—must be, because I have a strong sense of 'being at it'—it's a kind of film—this is a kind of script—something's punching the clock—

6.5 Her pussy smelled of warm cheddar Her pussy smelled of scrambled eggs and sulphur Her pussy smelled of a cross between anise and black pepper Her pussy smelled of addiction Her pussy smelled of a wet cat Her pussy smelled of melon water Her pussy smelled of wet leather Her pussy smelled of cotton with a spot of grain alcohol deep inside

6.6 Because it's hard work trying to tell the truth of an event—shake out the pieces with staying power—looking for the emblematic images—the telling movement—the things that will hold up to decomposition and recomposition—sifting through the blithe cinders—if I can't have her, then something of what's left behind

6.7 I fell in love with her in at least five different ways that roughly correspond to the makeup of a consciousness presently eating at the shell I had been, consuming me gradually from the inside out, leaving something new behind

6.8 A blinding decomposition that leaves me with a longing—teaching me at the same time that shell bound love is acquisitive—and that to do honour to that teaching is an ordeal bred of faith and misery—Or as my young acquaintance says, "Forget it. It's Chinatown."

6.9 Just before the end, she called me on my dissociative behaviour—"I know I'm dissociated. Look how I'm living!" At least you're in Vancouver, she said. Yeah. Mild climate. Anywhere else and I'd be dead a long time ago

6.10 You Make Me Transparent as the Weather

6.11 I've started collecting the lost animals posters people leave when they're searching for their pets—I think there's a film project in them somewhere

Epilogue

7.1 Wetness—desire—that makes a residence Indifference and DG flows

7.2 It's a wet world—But I'm dry today—seeking a wet spot -

7.3 I want to be visited the way people go to the beach—they ask nothing of it—except they can rely on it—but also they open themselves to mystery and surprise even though they know nothing much ever happens—it's the indifference of the water that makes that curious desire possible, I think—because that's how they make the image of the beach and their place in it

7.4 Yeah, I want people to want me and my movies like they want the beach in that way

7.5 We say nothing without interest—it's always been about desire finding its way through wetness

7.6 The machine manifests a new energy

7.7 I showed it to her—she hates it—she doesn't take it seriously—that makes me so mad—I'm humiliated—she can't be the arbiter of value—it must mean more than her dismissive glance allows—she doesn't get it—I have to remember to ask her how it makes her feel—she doesn't know that its secret function is that it's not at all useful—not to say useless, but as an image of the utilitarian, it's porous

7.8 But maybe it's just the machine I hoped would cause her to attach herself to me

7.9 I gave her that Libyan pillow—I threw out all my Camus—What happened to me? I used to be so interested in rebellion

7.10 The patent lawyer doesn't return my calls

7.11 BDC won't see me. My prototype works. What's wrong with people? Can't they recognize opportunity?

7.12 I wish I could menstruate—that way I could be distracted by the waters not of my own choosing

7.13 I'll call it a menstrual machine and so de-ego (not ego or releasing me by affliction affectation)

7.14 I would like to have more rules—laws if you will—some regulators

7.15 There are rules in the machine, things to follow, makers of success

7.16 I'm having a hard time in Vancouver—it has a notorious difficult social reputation—and so is its art a reflection of that?

7.17 "I wish you were more political," said my wife. "You can't trust a married man," said my lover. Hence my SRO exile on Main Street.

7.18 time to go

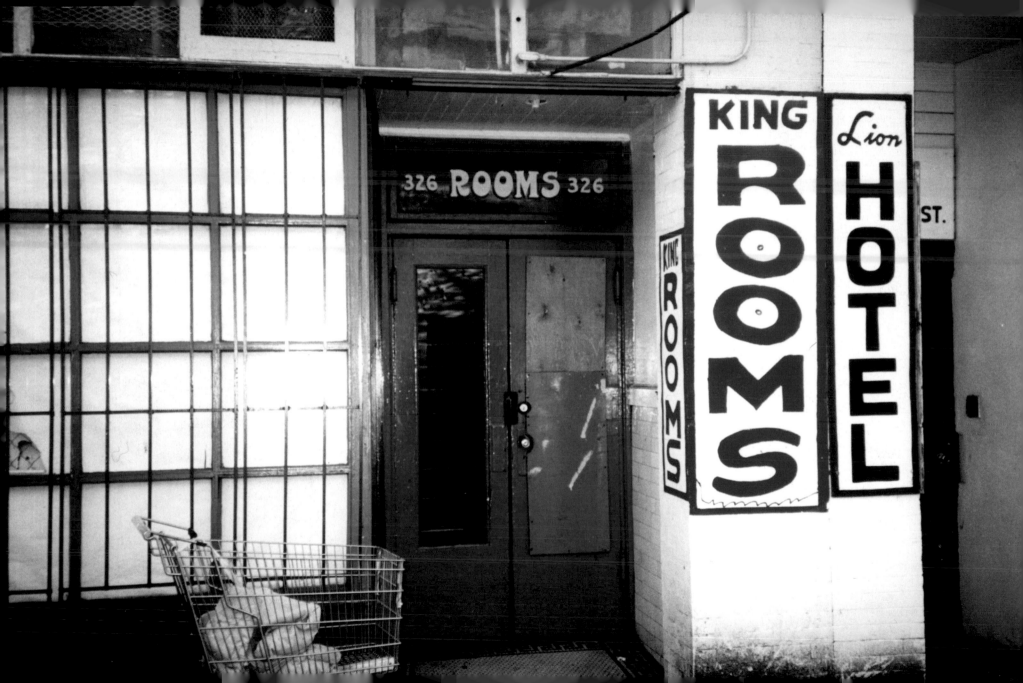

ANTICIPATION OF

I knead the knots in my right arm as train whistles signal crossings in the distance. Standing in a dark room with my hand on the camera body, ripples of mechanical quiverings from the optical printer penetrate the skin of my palm and travel the veinous track from hand to wrist to shoulder to spine, finally taking up residence in the small of my back where the whirr and hum of the machine linger and resonate like the deep base rhythms of loud music and passing locomotives. I engage my body with filmic machines fallen into disrepair; forgotten about and pushed aside to the back rooms of labs, schools, and co-ops making room for newer, 'cheaper', 'more versatile' digital technologies. These machines ride on the heels of an industrial age once said to alienate the worker from direct production: looms, canneries, presses, steamships, and trains where fathers worked amidst oil, smoke, squealing brakes and the grinding of gears; where they stood as operators while levers and drive shafts stepped into the line of direct production, alienating efforts from results. Ironically, the analogue and mechanical descendents of these industries now draw the operator back to her bodily senses, while contemporary digital technologies reduce the range of bodily movement even further than the industrial technologies of the last two centuries. Where once we used our whole bodies—raking, hoeing, hoisting, pulling, pushing—now we sit statuesque in posture, only our fingers moving on the keyboards in set carpel tunnel choreographies, our kinesphere growing smaller and smaller with the advent of each new techno-toy.

To revisit these mechanical processes now that it is no longer necessary to engage in them—now that there are more 'efficient', less physically demanding/engaging modes of production—can actually perform a sort of anti-alienation, triggering and exciting our physical bodies as they inscribe maps of remembered experience and sensuous geographies into the flesh, through the skin which serves as a thin penetrable film between the sensor and the sensed, baring traces, lines, and scars of past contact.

For those of us who have chosen an analogue practice in a digital age, there is a direct physical impact on our bodies resulting from repetitive physical patterns, exposure to toxic chemistry, and working long hours in the dark. There is also a direct social impact on our economic behaviours, as we work on the outskirts of the capitalistic entertainment industry, scavenging for materials and supplies that are beyond our financial means. We shoot Super 8 and cheap 16mm optical sound stock not meant for recording picture, we find short ends for free from various industry shoots, we process it all ourselves in our hidden darkrooms and bathrooms. We find old discarded equipment from schools and labs, from dumpsters and on E-bay—we restore projectors and contact printers, create mutated Franken-machines from miscellaneous parts and ply our art after dark when 'light-tight' is easier to find.

AMANDA DAWN CHRISTIE

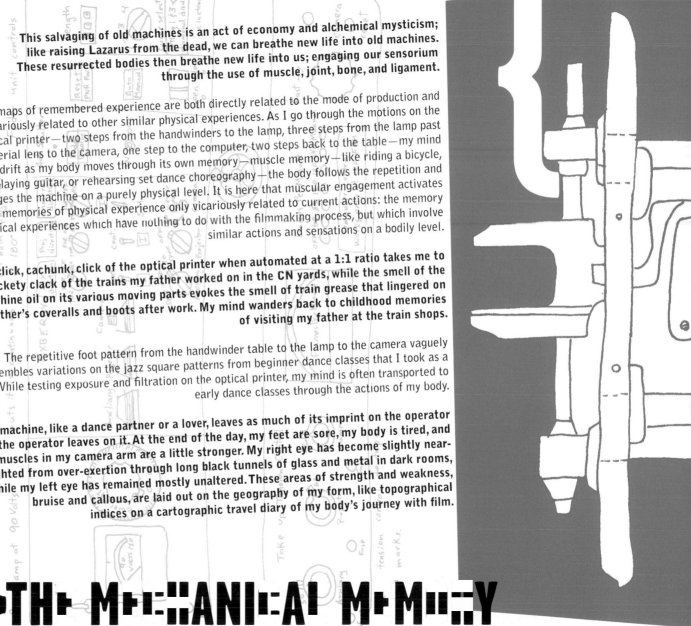

OXBERRY®

Filmaker 16mm Animation Stand and Camera

MODEL 5332-00

INSTRUCTION MANUAL

BERKEY TECHNICAL
25-15 50TH ST... SIDE. N.Y. 11377
SALES AND SERVICE OFFICES ...CHESTNUT STREET, BURBANK...RANK RD., MALTON, ONTARIO...LL WAY, THETFORD, NORFOLK

A DIVISION OF Berkey Photo Inc.

This salvaging of old machines is an act of economy and alchemical mysticism; like raising Lazarus from the dead, we can breathe new life into old machines. These resurrected bodies then breathe new life into us; engaging our sensorium through the use of muscle, joint, bone, and ligament.

The maps of remembered experience are both directly related to the mode of production and vicariously related to other similar physical experiences. As I go through the motions on the optical printer—two steps from the handwinders to the lamp, three steps from the lamp past the aerial lens to the camera, one step to the computer, two steps back to the table—my mind can drift as my body moves through its own memory—muscle memory—like riding a bicycle, playing guitar, or rehearsing set dance choreography—the body follows the repetition and engages the machine on a purely physical level. It is here that muscular engagement activates other memories of physical experience only vicariously related to current actions: the memory of physical experiences which have nothing to do with the filmmaking process, but which involve similar actions and sensations on a bodily level.

The click, cachunk, click of the optical printer when automated at a 1:1 ratio takes me to the clickety clack of the trains my father worked on in the CN yards, while the smell of the machine oil on its various moving parts evokes the smell of train grease that lingered on my father's coveralls and boots after work. My mind wanders back to childhood memories of visiting my father at the train shops.

The repetitive foot pattern from the handwinder table to the lamp to the camera vaguely resembles variations on the jazz square patterns from beginner dance classes that I took as a child. While testing exposure and filtration on the optical printer, my mind is often transported to early dance classes through the actions of my body.

The machine, like a dance partner or a lover, leaves as much of its imprint on the operator as the operator leaves on it. At the end of the day, my feet are sore, my body is tired, and the muscles in my camera arm are a little stronger. My right eye has become slightly near-sighted from over-exertion through long black tunnels of glass and metal in dark rooms, while my left eye has remained mostly unaltered. These areas of strength and weakness, like bruise and callous, are laid out on the geography of my form, like topographical indices on a cartographic travel diary of my body's journey with film.

{ THE MECHANICAL MEMORY

About twenty-five years ago I made a pilgrimage
to the calico textile museum in India which houses
one of the world's greatest collections of textiles,
and I understood something that would, in time,
shape the way I worked.

What impressed me wasn't so much the
craftsmanship of all those enslaved women, nor the
breathtaking amount of time that had been taken up
by their hands, but the extraordinary intelligence
and empathy that had woven or sewn itself into
what evidently were works of a collective tuning of
their minds.

Beautiful things contain a symmetry of everyone's
relation to one another.

A friend asked me recently to describe something
about the work I make. She meant something
about its organising principles, and I said, rather
opaquely—but it was the word that came to mind—
that it had to do with hapticity, that deep and
sympathetic intelligence which passes through
the hands and replicates something of the mind at
work.

I work with textiles and with digital imaging
systems, the same can be said, I think, of both;
they are the canvasses for exploring the dynamics
and properties of thinking as it is thought, the
patternings of it.

My hands are the recombinating tools of my
mind. In the grasp, quickness and motion of
them—whether by using final cut pro, a sewing
machine or a needle—there is an absolute sinking
in and through to a compassionate and lucid
intelligence in my hands, a kind of perceptual
leaping that assembles feeling and understanding
for something, not just the idea of them.

SARAH BUTTERFIELD

In this full space between my dreams and the
physical world, the shapes matter, the traces, th
dropped threads, the patterns and the errors

This (psycho)dynamic connectivity betweer
hands and the mind is developing in interesting
ways as technology speeds up: the Internet i
potentially deeply haptic

There are some givens about this fabric web: no
one anticipated that more would be put in to the
Internet than would be taken out: creation i-
therefore happenning, on the inside

The long tail of this content is continuous and
linked, its rhizomatic nature and the great speed
at which vast amounts of stuff is moved and
manipulated obliges exchange and conversation

As boundaries between become invisible and
liquid, institutions will become conversations

Its conversational nature contains an elegan
sifting mechanism, by this things prevail, belie
endures from being open to opinion and constan
modification.

Beautiful things contain a symmetry o
everyone's relation to one another

So it would seem that dropping threads into thi
web, giving up discreetness & ownership, seeding
calm and elegant things across its surface
and depths—just as the women of the calico
museum did all those years ago—would cohere
into a tuning of the already existent patterning
of our collective awareness. Perhaps only by
participating this way fully with our mindhand
will we begin to recognise the essence of ou
present enlightened false consciousness

What

Nature Mort

still life(s) done on a Wednesday

FIONA BOWIE

00:01:01:23

00:02:10:04

00:03:32:23

Nature Mort, Segment 1
(7pm)

Maintaining decorum (moment reinterpreted with vegetable).

00:04:14:22

00:05:33:04

00:06:21:13

Nature Mort, Segment 2
(7 Months later)

...a seagull just above the traffic is headed west. With each downbeat of its wing, it bobs upward and forward then down
again through the reciprocal upbeat. Almost a see-saw motion. Really odd (poor thing). So determined (what else could it do).
I crane my neck as it passes over my windshield.

00:07:03:20

00:08:13:07

00:09:07:00

Nature Mort. Segment 3
(Not much like a caught fish or a peach; no silver bowl, nor grace of brush. poor bee.)

...I sat beside a US intelligence officer once. He had a very heavy carry-on (could barely hoist it into the luggage bay above) and was en route to Colombia. Didn't talk much about himself, but learned a lot about me. I couldn't stop thinking about that bag.

if it is

had been co-opted into some sort of Greenbergian justification for abstract expressionism. In my graduating thesis I argued that Greenberg had it all wrong and that Monet and Cezanne were primarily concerned with the problem of representing time. The painterly brush strokes, I argued, were merely the by-product of the process. In the painting studios this attack on the high priesthood of American painting was only slightly less reprehensible than painting figurative landscapes, but my fate as a painter was not completely decided until I tied the department's only Regular 8mm camera to a tree and let the wind make my first film.

Nearly twenty years and thirty films and installations later, I immigrated to Canada in an attempt to "extend my ideas beyond the European concept of Landscape Art," the burden of history which had inevitably been the context for my practice to date. I had visited Vancouver on a number of my film tours and it seemed to me that this was a place where landscape really would be a more urgent, politicized and day-to-day issue. It is perhaps symptomatic of my hopes that my first (and only) film screening since moving to Vancouver was a charity screening for the Western Wilderness Committee.

During the last two years I have been working on a series of installations that explore the possibility of using real-time weather data to edit picture and sound. Digital technology allows me to take the ideas I began to explore in my early interactive works such as Windmill or Seven Days, into a whole new area of possibilities. The early films are records of specific periods of time

Along with approximately half the population of the planet, I have lived most of my life in cities. However, the forests and tidal estuaries of the south coast of England were my first home and the subject of my first paintings and drawings. I painted these subjects because that was where I lived, and because of a deeply experienced connection to the land and the sea.

When, in 1972, I became a full-time art student at Chelsea School of Art in London, I was given to understand that landscape was not a suitable subject for art-making and, temporarily swayed, I threw myself into the task of making large colour field abstract paintings, after the style of Frank Stella and later Mark Rothko. Thanks to a course on photography, however, I soon found myself out in the landscape again, ostensibly searching for imagery to put into my "abstract" paintings.

Photography is all about time, as is the landscape, and in the artistic climate of the early seventies it was not difficult for me to make the necessary connections. I was fascinated by John Cage's music and writings and rumors of the experimental video works of Nam June Paik began to take form in my imagination. Meanwhile, in the art history department, the post-impressionists

102

CHRIS WELSBY

during which the filmmaking equipment and interactive devices such as the windmill or the equatorial stand interact with the wind and changing weather conditions. The ideas that informed these works were quite abstract and philosophical; explorations of the relationship between nature and technology and the comparatively simple mechanical devices of filmmaking were a perfect medium for this line of inquiry.

In the more recent works, using video and digital technology, the interaction with nature takes place in real-time, in the gallery; there is no record of the event but instead, each viewing moment is completely unique and irrevocably rooted in the here and now of the viewing experience.

I have recently moved from the city of Vancouver to a small island off the coast of British Columbia. Sparsely populated, it supports a few farms carved out of the coastal rain forest, and an underdeveloped tourist industry. It has a couple of grocery shops, three police officers, a volunteer fire service and no Starbucks. The island is nonetheless zoned not as a geographical entity surrounded by water, but as a city. It appears that moving to the country requires more than a change of geographical location.

Administrative expedience perhaps, and yet this seems to be symptomatic of a long and ingrained habit of thought which seeks to separate Nature from Culture and place human activity at the very centre of our cosmology. The city is vast but, like the inhabitants of a medieval city, it appears we still live in fear of the world outside the walls, in a state of denial, huddled around our hearths (televisions and computers) whilst the forces of an abused nature gather menacingly at the gates.

Echoing this scenario, pictorial conventions ranging from the renaissance fresco to the feature film present the landscape as little more than a backdrop to human activity. It appears that the dualist malaise runs deep within the human psyche and finds expression in all levels of language. Using experimental film, video, and digital media, I have endeavored to reverse this pictorial order, placing the landscape in the foreground and re-position human activity, (including my own as filmmaker), back within the scene, not as a protagonist but as a participant in a process where technology, landscape and creativity are part of a larger more inclusive ecological system.

Waiting for the beginning: the body and the screen in new media

Clint Burnham

1. Thus Kate Craig declared of her 1983 video *Still Life*, that it was "the antithesis of commercial television" (Western Front Catalogue, 1983, qtd. Knights 171). In Karen Knights' survey of video art at the Front, she devotes much of her time to discussing production, content, and distribution, but neglects to analyze the presentation of video, i.e., the difference between art video and television is established in terms of production, not reception. Jennifer Abbott, in "Contested Relations: playing back video in," characterizes (commercial?) television as "video's technological parent" (22), but also problematizes that connection: "Precisely because of its shared genealogy, independent video explicitly or implicitly critiques television, while at the same time desiring its magnitude, its power, its elevation from being 'of culture' to being synonymous with it. It craves the power of its distribution, fears the danger of its co-optation, while vehemently denouncing the socially pacifying consequences of its content. Video was literally and metaphorically turned on by TV. It wants, even needs it ... and then again, it doesn't." As with Knights' text, Abbott's does not deal with the presentation of video.

2. "I was probably talking about the fact that a painting ... presents people with the problem of how long to look at it. Should they wait for it to change (it won't) do they wait for an 'experience' (that is, a change in themselves). Are they ridiculous for looking ... but video answers that by continually changing, so you don't have to worry about a certain kind of response because, in a way, it is always responding to itself and the answer to why you are looking is that it is changing. And the more the installation is theatre-like, then the less you have to worry about your body in space etc." (email from artist, May 29, 2006).

3. "Anyone who reads much about contemporary art will have frequently come across some version of the following mantra: this work of art/this artist's work/the art scene as a whole transcends rational understanding, pitching the viewer into a state of trembling uncertainty in which all normal categories have slipped away, opening a vertiginous window onto the infinite, some traumatic wound normally sutured by reason, or onto the void" (Stallabrass 8).

I:

Many commentators on video art seek to make distinctions between video and the mass cultural: this is in effect a modernist hangover, as it were, a residual (as Raymond Williams would say) effect of the Adornoesque disdain for mass culture that still haunts the political imagination of the cultural critic. Nowhere is this so evident as in some of the critical discourse around the Western Front and Video In, where in the 1970s in particular the ability to use new technology encouraged artists to think outside the box of network television.[1] Of course, thirty years later, network television itself may well be a dodo, done in by the combination of narrowcasting/niche marketing on specialty cable networks on the one hand, and on the other hand, DVDs and the Web-based "revolutions" of TiVo and YouTube.

If the target has moved, so too, it would seem, must the strategies. But what are the strategies—that is, why worry about what is on BCTV tonight (since *most* people won't be watching it)? In some ways, a monolithic enemy (corporate media) is more comforting than a dispersed (war of position, as Gramsci would say) variety of enemies—from ennui to downloaded kiddie porn, from blogs to DVDs you mail back.

But let's take another tack. Theorists and artists of video have also made claims for some distance from the home or theatrical viewing subject—its *habitus*—in how we look at video in the museum or gallery. Vancouver artist Judy Radul, for instance, in an artist's talk for her show at the Presentation House Gallery in 2005, said that part of her motivation for her current work had to do with thinking about how long we stand in front of a painting—how do

we know, she wondered, when you can move on? Indeed a painting, like a poem (as opposed, on the one hand, to film/video, or on the other, to the novel), leaves it up to the viewer to decide. This is both anxiety-inducing and a hallmark of cultural capital.[2]

Boris Groys, writing in *Last Call* in 2001, remarked that the truly radical potential of media art in the museum was not its potential to either democratize or dumb down the institution, but rather how it entailed a shift from the contemplative stance of the viewer in front of a sculpture or painting to a battle or antagonism between the viewer and the artist. That is, whereas with a painting, an artist has spent a certain number of weeks or months on a work that the viewer can consume, as it were, in a single glance, the tables are turned with media art, and the viewer is thrown into uncertainty: do you walk away, come back, stay, leave right now? As Groys writes, "It is this fundamental uncertainty when the movement of pictures and viewers happen at the same moment that creates the increased aesthetic value."

That claim for the indeterminacy of the subject is very nice, of course, but so prevalent that one wonders if Groys' "fundamental uncertainty" is just another easily consumable commodity for the elite art-going public.[3] Sven Lütticken, writing about Dutch video artist Erik van Lieshout, at least situates this uncertainty in a physical space: "van Lieshout's videos are often shown in huts or shacks that are starkly opposed to the elegant minimalism of art spaces: as intimate spaces within the exhibition space, they are a strange blend (of) the cinema and the living room, between film and TV" (7).

In counterdistinction to such enclosures, Judy Radul and Shirin Neshat have both made works that call upon the viewer to move his or her body in relation to the work.[4] In Radul's *Downes Point*, which was on view at the Presentation House Gallery in the fall of 2005, a director conducts a casting call or rehearsal in the forest, and a line of actors try out in front of him, then goes off in one direction or another. Using the optics of the camera's visual range, Radul films the actors so that they disappear between sections of the shot. Images are projected onto screens facing each other. The viewer can stand between them and keep turning around, or s/he can stand at the side and look left and right, the tennis game gambit. The place of the viewer's body is then integral to the meaning of *Downes Point*, for when facing the director, the viewer becomes another actor (we are addressed by the director), and when facing the actors, the viewer now stands in for the director (the actors look at us expectantly). If we are thus interpellated *à la* Althusser (that is, hailed into being as viewers of this video), or even theatricalized in the way that Michael Fried hated so much, Radul's work also, as Monika Szewczyk notes in a review in *fillip*, traps us in a rectilinear geometry of viewing: figures move, ghost-like (recalling Groys), between the seams of different camera angles. Thus our very body's discomfort with the space of viewing is anticipated by the work itself.

In addition, there is a relation between the pastoral space in the videos—British Columbia's Hornby Island—and the pristine space of the gallery. These spaces are antagonistic, but they are both also internally so. Hornby Island has been colonized by the casting call/rehearsal. So, too, the gallery has become a site of visual longing for that pastoral space.

Similarly, Shirin Neshat's video works from the 1990s take place on facing screens. Neshat's work is binary, typically dividing the screened worlds into male and female. Thus in *Turbulent* (1998) one screen shows a man singing to an auditorium of men in white shirts; he is singing a traditional love song by the Persian poet Rumi. On the other screen, Sussan Deyhim sings a song of her own composition. And in *Rapture* (1999), one screen shows men in office attire in a Moroccan fort, while the other shows women in chadors in the desert, eventually hauling a boat out to sea.

The place of the body in relation to these images both is and is not as radical as that with respect to Radul's *Downes Point*. There is no point of aesthetic identification or integration in Neshat's work as exhibited: rather, the indeterminacy of viewing comes to be an allegory for the West's lack of position vis-à-vis the Muslim world: we either identify with the women's subjugation, in which case we call for military action, or we stand with the masculinist supremacy, in which case we are misogynist pacifists. It's a loser-wins scenario.[5]

II:

The uneasy or uncertain body of the viewer is joined by a narrative queasiness. As Groys and Lütticken have argued, the spartan nature of the viewing room is related to the looping nature of much contemporary video art. That is, since there is no beginning or end, you can come or go as you please. In this way, the work conjoins that of the early nickelodeon days, when the mass viewing public would come and go in the theatre, a practice that continued into the 1930s and '40s when films were shown continuously in movie theatres.

4. Part of the effect of video art that engages (activates?) the viewer in the way that Radul's and Neshat's art does, is that the "edge" of the work, its frontier or limit, becomes fuzzy: is the viewer part of the work when their viewing stance changes?

5. The reader will have noted that the indeterminacy I am finding in Radul and Neshat is of a different order than that parodied by Stallabrass: this indeterminacy actually is rational, it is connected to social conditions – whether hierarchies of theatre and art (Radul) or geopolitical allegories (Neshat).

I think we should also make a distinction between works that are genuine loops, that is, with no title cards or indication of an ending/beginning, and those that, while programmed on the DVD player to loop, nonetheless do possess a linear structure (even if only materially, and not in terms of narrative). The latter is the case for Damian Moppett's 2002 video *1815/1962*. In order to capture the interpretive dilemmas one is faced with in watching Moppett's work, here I reproduce notes that I made while viewing the video in a museum in 2006, along with a meta-commentary.

3:39 rain, back to camera, sitting
3:40 gets up
Then: Dry?
Walking by

We can see that as my notes begin they are cryptic—it is the figure of Damian Moppett (himself? playing a character? but in "costume"—of which more later). The notes return again and again to his body, his clothing, and, of course, the weather. Even as my body was static, leaning against a wall, kneeling down. These are real-time notes.

3:41 walking towards us
he's
silent
bearded
nothing clothing

How is the video different if you have seen Moppett, if you know him/know what he looks like, versus if you simply see the video cold? Again, a kind of unknowing is at work here— we cannot know how those with different cultural capital would know, what they would know—and this is also a different relation than with either a known film/tv star, or an unknown extra.

3:43 pan down tree
windy/noisy
hard to see depth in
field ...

The ambient sound and the visual field place the viewer in a sense that is analogous to Moppett's character: out of orientation.

3:44 DM chops down tree
sanding
sharpens end w/
hatchet
silent
sleeping
wakes up

This action, then, is sudden, unexpected, violent. It's both puzzling (why cut down a tree, what is going on?) and realistic (that's what you do in the woods). The cuts to Moppett sleeping and then awakening introduce a temporal rift in the video.

3:46 checks trap
knots

Why this trap? There is a model in the corner of the room in which Moppett's video plays. Critics have commented on how Moppett's character is making a sculpture in the manner of "Anthony Caro's 1962 sculpture Early One Morning*"[6] and that Moppett's gesture in turn traps Caro at a certain historical juncture, between the waning lights of late modernist sculpture a la Moore and the tumescent*

106

6. Trevor Mahovsky, *Artforum*, April 2004.

morn of '60s minimalism.[7] *When we see Moppett tying knots, we are witnessing, in effect, the ineluctable fraying of our own interpretive capacities.*

3:47 larger structure
net in frame
3:48 larger structure
net in frame

The repetition here is important for how it marks my own uncertainty—in watching the video—as to what I am seeing has just happened, is about to happen. I am trapped in the room watching the video (trapped, it should be said, by the desire called interpretation). Too, the "larger" marks a growing interest on the part of the viewer (subjective) as well as a growing size (objective).

3:48 returning modernism's
minimalism to use?

Moppett's riff on Caro, his pastiche of modernism, should not, these nouns notwithstanding (the one borrowed from music, the other from the orthodox vocabulary of 1980s Jameson) mislead us into thinking that Moppett's work is postmodern. Perhaps, really, it is pre-modern, or anti-modern, in its refusal of the uselessness of art. Recall that Adorno, in Aesthetic Theory, *calls the use value of art its lack of use; art is the absolute commodity in that, unlike the commodity, it does not pretend to exist for any reason,[8] But a trap has many meanings, many functions, from an animal trap (Ban Leghold Traps was a common refrain in the 1980s) to Maria von Trapp (of* The Sound of Music*) and thence to the vernacular "shut your trap."*

3:49 also victim of amateurism
Gilligan's Island
bricolage

Moppett's interest in the amateur comes to a head in his 2005 exhibition The Visible Work, *in which he assumes the guise of the amateur potter. Thence too the forms of bricolage, which is often used as a synonym for a handyman. The* Gilligan's Island *reference (I was thinking of such inventions as the bicycle-powered blender, as well as the bumbling nature of the show's eponymous hero) reassures us that, try as the white cube might, it can never really keep the nefarious rays of commercial television or popular culture out of our memories.*

3:50 tries out "trap"
3:51 tinkers, leaves trap
3:52 end
1815/1962 (2003)

Here what interests me is how the ending and the beginning are nearly synonymous. I think that I probably only knew the video was "over" because it began again, in the same way (to anticipate) that I only knew I'd "seen it all" once I began to see the same thing again. But unlike the end of a film in a theatre, when we gather our jackets and empty popcorn tubs, the end of a video loop means now we can begin. Now we can begin to look, to see if there is a linear narrative.

3:52 sound of RAIN
editing in & out
of focus
he's silent, but
video isn't

7. Michael Turner (writing as "Charlie Munter," an anagram of his name), pamphlet accompanying the exhibition of 1815/1962 at Catriona Jeffries Gallery, Vancouver, 2003.

8. "If artworks are in fact absolute commodities in that they are a social product that has rejected every semblance of existing for society, a semblance to which commodities otherwise urgently cling, the determining relation of production, the commodity form, enters the artwork equally with the social force of production and the antagonism between the two." (Adorno 236). Note that Turner's text on 1815/1962 cannily plays on this antagonism by posing as a letter from a producer of industrial "lifestyle" films, thus bringing Moppett's freeform work squarely up against the commercial other. In effect, I am returning here to the anxiety vis-à-vis the market that I criticized in the first part of this essay.

352
1 8/5/1962 (2003)

352: Sound ~~of~~ RAIN
amplify in a ∂et
of pours.

Le's silent, but
video isn't.

353 hatchet is hot
DMcleen out kes

354 more rain.
but almost le
inaudible
ea. close up.

loop. ~~l hit~~
hi? hard to us
light on him
(Christ)

355

k h is over is wa
(rain).

When is the shirt, tail
clean & dirty?

DM 56 - wall stuff OR
& bonus - custom.
98 6
99/100 CJ photos?
bounce.
05 CAG

I inspiration for Jack Rabul.

film sounds anyels, wind
rain, footstyps.

Again the role of the sound. Because there is the appearance of ambient sound, or the sound of ambience, the video gives off a DV verité that is also obviously an effect, a trope, a rhetoric. What the mise-en-scène of the video does is to instill a doubled suspension of disbelief: first of all, obviously, we are not witnessing a scene from 1815 or 1962: this is a costume drama; secondly, the rift between the costumed figure (Moppett) and the contemporaneity of the video production insists on the "realism" of the scene. Thus the viewer's disorientation is doubled—we are both uncertain as to when things begin or end, as well as to "when" the video takes place (this second uncertainty is further torqued by the anachronism of a protomodernist artefact being crafted in the 19th century, a dumb-literal reading that Turner parodies in his text).

3:53 hatchet is ?? (unreadable)
DM checks out trees

A meta-metacommentary: Stanley Cavell once remarked that films exist primarily in our memory (this was before the age of VCRs). In the same way, interpretation exists primarily in the faulty pages of our notebooks.

3:54 more rain
but almost
invisible
ex. close up
loop
his back to us

We can often hear the rain in the video, but do not often see it—a condition that is common in "real life" on the West Coast. When I used to work in a building at UBC, I would look at lower buildings' roofs before leaving for the day, to see if there were raindrops

on the puddles, to know if it was raining. And while these notes replicate closely my notes from when I began seeing the video (**3:39 rain, back to camera, sitting**)*, the iteration here recalls both Gertrude Stein on repetition (there is no repetition, she insisted) and Lacanian theories of the symptom. For on the one hand there is, indeed, no repetition in the video itself, but only in its screening; on the other hand, that very repetition in the screening, in the presentation of the video, is anticipated in the loose narrative of the video.*

3:55 light on him
(Christ)
3:56
walks in & out of camera
not in order: shirt
(rain)
When is his shirttail
clean or dirty?

Now there is also a turn towards exegesis: or my fixation on Moppett's clean and dirty, wet and dry, shirt. These are attempts to determine narrative time, or to determine if there is a causal narrative in the video itself; but of course they can only do so by assuming that the fabric of the character's clothing behaves in a linear fashion—is dry and then wet, or clean and then dirty. Like the museum-goer who can only guess at when a video began or ended (using the social time of the museum to gauge the narrative or fictitious time of the video). Then, a comment on my use of time here—the notations that track the video with the chronological or social time of day in which I was watching it.

DM 96—Wall stuff OR
bonus—Guston

98–6
99/00 CJ photos?
bounce
05 CAG

Here my mini-cv of Moppett's exhibition record, or work that I have seen, attempts to fix this work in the time of the artist's production.

Inspiration for Judy Radul

Radul's Downes Point *was inspired in part by 1815/1962.*[9]

film sounds, animals, wind
rain, footsteps

what/who is he
trying to trap?
viewer?
animals?
Caro/art?
himself?
—loop
comes out of sleep
but (unreadable) ax?

like how he made
-sculptures
-photos
-ceramics

DIY, pro, outsource, amateur

could anything be

trapped?
"end"—dirty shirt
15 mins.

END OF NOTES

Here we have a combination of attempts to figure out what is going on, give it a narrative, causality/time, and assemble a critical framework; memory. But what is striking is how, after the video has looped (has it ended? have my notes ended because I no longer am thinking about the video? can the end of my notes only begin once the video has looped, once it has begun its own ending?), the lack of certainty really begins.

9. See my review of Radul's exhibition at Presentation House Gallery.

Works Cited:

Abbot, Jennifer. "Contested Relations: playing back video in. *Making Video 'In'*. Ed. Abbott. Vancouver: Video In Studios, 2000. 9-32.

Adorno, Theodor. *Aesthetic Theory*. Trans. Robert Hullot-Kentor. *Theory and History of Literature 88*. Minneapolis: U of Minnesota P, 1997.

Burnham, Clint. "Images yield poetry in motion pictures." Rev. of Judy Radul at Presentation House Gallery. *The Vancouver Sun*, 22 Sept, 2005, p. D24.

Groys, Boris. "Media Art in the Museum." *Last Call 1:2* (2001). http://www.belkin-gallery.ubc.ca/lastcall/past/pages2/index.html. Accessed August 4, 2006.

Knights, Karen. "The Legacy of our Polymeric Progeny." *Whispered Art History: Twenty Years at the Western Front*. Ed. Keith Wallace. Vancouver: Arsenal Pulp Press, 1993. 163-177.

Lütticken, Sven "Erik van Lieshout's Video Shacks." *A Prior 12* (2006), 6-9.

Mahovsky, Trevor. "Damian Moppett: Catriona Jeffries Gallery." *Artforum*, XLII:8, April 2004.

Stallabrass, Julian. *Art Incorporated*. Oxford: Oxford U.P., 2004.

Szewczyk, Monika. "Departures from Death." *fillip 1:2*. http://www.fillip.ca/content/szewczyk. Accessed August 4, 2006.

Turner, Michael. 1815/1962. Vancouver: Catriona Jeffries Gallery, 2003.

LUNG: toward embodying

112

Ambitious and weary of his barbarian princess Medea, Jason arranges to marry the daughter of the King of Corinth. The desertion and ingratitude of the man she loves rouse the savage in Medea and her rage is outspoken. Fearing her vengeance, the King banishes Medea and her two children to exile...

I begin with a spin because each and every tale spun matches the machine we use, literally spinning 8x, 16x, 32x, 48x...I join this spin, turning it into dance. I will spin words, weaving them to be a dance of words, turning meaninglessness toward an unknown, an unpredictability and lack of predetermination, so a meaning unveils itself without my individual will or intentionality.

A spinning dance with a spin of the body: a re-embracing of bodily being to counter our Cartesian trap of bodily obsolescence, sedentariness and erasure of the values and inherent skills of a somatic being. As the machine dances its spin faster in every new version so too are we spinning, bodiless, captured by the hysterics and neuroses of every crash and freeze caused by its lacks. With a laser Cyclop-tian eye, it scans for data while surveillantly adapting my every move to an informaniacal tarantella with its heartless and futile pace.

I long for lung. Clear lung. Clarity. Not the moist thick fog of a pneumonic constriction guided by the plaintive warning of a one-eyed Cyclop-tian lighthouse /

Instead I dream of the expansive lungs of open savanna, fields of dry harsh grass cutting the skin with touch. Blossoms dried to prickly pear and brown brush rush bush. Of spiders clambering with a meticulous pace through their webs to catch a pest of meaning, to eat, to nourish, to poison the gift of sentimentality, of do-wellers on a not-so-secret mission to do *good*—lecturing authoritatively to manage a citizenry.

"A hurricane is a hurricane and we've seen its devastation" said the Florida governor last night. It went in one ear and out the other and I thought nothing of it. At his podium, well dressed, every one-eyed Cyclops aimed to record his every word; it was made to appear as if he cares about 'devastation', as if he bodily *knows* devastation. Then my lung brain rewound and replayed and I registered how nothing was registering...uh oh, the numb lung of a televidual one-eye. What he said was too obvious to have meaning. Yet in media, this attention in itself, zooming into his image, represents profundity; he is to be profound, meaningful, even if mundane, inane.

Media, with its current pace and pant, are a fast spin of words and tales. Spinning a tale, chasing a tail—the propellation of the unthinking brawn of the one-eyed laser / again, with a patrialogic to keep the citizenry in place /

To be un-numb is not to be a machine in a blind propellation. We see this increasing. Informaniacal collecting of data to direct our lives, our desires, our consumption, our future terrorists, our panic level. Ailing lung: a panic of fear (*allergy*), grief (*asthma*) and suffering (*pneumonia*). With the speed of an ever-mutating bacteria and the sluggishness of a diseased bodily fatigue—a habituated consumption (I suggest *tubercolossal*) growing cells of fears, tears, grieving of what is lost, a panic of what is yet to come.

This is stressed lung / without breath / oppressed, un-empowered / celluloidal stress manifest in the flesh / cutting immunity through helplessness, melancholia, Prozactal

and Ritalinoidal glum / we resort to consuming self and others, of objects, informatics, instantaneous pharmacologics, retail therapy and other escapes / we unlearn the ability of tenacity: the tenacity of bodily duration and patience / the patience of a breath within a listening to an expansive temporality /

Yet, how do we imagine what is yet to come? How do we learn this imagination? Do we only know imagining by what, as children, we learnt or can we grow a new method, approach, syntax, vocabulary? An un-numb lung will not breathe numb questions or succumb to suffering or grieving silence. Instead, it is present, feeling, visceral, somatic, humorous (for laughter is bellyfull), generous, empathetic, compassionate. Improvisational without plan or expectation in every moment. To not be machinative or pre-emptive—we had learnt this from the King who 'pre-empts' any movement of Medea solely because of *his* fear; as from Jason, we learn how to be ambitious *through betrayal* /

here then we return to quality of spirit for it is the heart of our concern /

Chinese philosophy, as in the Mustard Seed Garden Manual of Painting, adapted here to apply to our subject, suggests: *the secret rests basically in the circulation of spirit* (ch'i yün) / *flowers should have a variety of positions; front, back, and side views / if they are to make an agreeable composition, they should be placed naturally* (tzu jan) / *the hand should move like lightning; it should never be slow or hesitant* / to clarify, *the circulation of spirit* is whole-bodily not solely of vision, hand-eye, or cleverness and intellect / an understanding of 'spirit' is that it is *physical energy* which includes one's vitality of character and is not from a religion of any kind: this must remain clear /

Vitalised character and un-numb questions are an agency of empowerment and a communal vision of the world for self and others. It questions the pharmacological machine and its instantaneity in naming and administering chemical machines toward a numbing pathology: the panic of stress / diverting us from what is real, which is: breath / nothing else will keep you alive /

Every event and media is a phenomenon. I breathe each phenomenon into un-numb lung (*breathe in dark: breathe out bright)* investigate it, find its relationships and representations *(why this, now— what does it tell me of me?)* and with this, relate the appropriateness of

the media to the context and content. Each machine is anthropomorphic in character, corresponding with and revealing values / consciousness, each of our values / consciousness: each choice we make mirrors us, character flaws and all—personal, societal, global.

Medea is of the world—alive, orgasmic, savage, straightforward, honest, and passionate with conviction. She is not in awe of telelogics and its distancing machinations. She will discard them at whim. Neither is she in a one-eyed spell. She spins a dance of her own. She redescribes clear fields of lush bush and fiery red twilight—enraged, engaged, critical, nurturing and nourishing a new curiosity: killing passivity, inviting engagement, collaborating in the world without the need to fix, own, contain, control, convert or detain, but aspiring to a community of free thinkers who love monstrously and viciously to keep awake / while she, in turn, is loved /

A return of a new Medea, enchanting an alchemy of magical seduction, total bodily joy (an exchange of cells) *and/ or wounding* (a revolutionary punctum with a graceful ch'i), *to thrill, orgasmically a jouissance* /

vancouver condo projects
reimagined as
experimental media art

TV TOWERS
778 Hamilton, Concord Pacific

"Cutting Edge homes on your wavelength."

An eight storey pod constructed from recycled cathode tubes that uses MAX/MSP to generate haunting, impressionistic images of Ian Hanomansing.

A robotic sculpture that struggles fruitlessly with a giant piece of canvas in an effort to explore the subject of mass nouns.

"A vanguard and deluxe development that transcends what is already here and what is yet to come."

L'HERMITAGE
788 Richards, Millennium Developers

EAST
E. Pender @ Columbia,
Bob Rennie & Associates

"A unique opportunity for modern living in a vibrant downtown district."

A 40,000 cubic foot foam pinata in the shape of Hello Kitty that displays live surveillance footage from the Downtown Eastside.

A political sculpture where visitors bathe in warm pools, wear bathing suits constructed from sustainable materials, and consume miniature flan.

"A magnetic union of Vancouver's fashion and style."

RAFFLES ON ROBSON
Robson @ Cambie, Bob Rennie & Associates

ATELIER
833 Homer, Magellen 2020

"Soaring ceilings with three storeys of breathing room."

A large inflatable structure that displays images of transitional passages.

KATE ARMSTRONG

ELYSE

Scotia @ East 7th, The Eden Group

"Serene amenities and rejuvenating bathrooms."

A monumental walnut console that stores and displays Slow-scan television performances.

An architectural multi-channel installation in which cameras are filmed filming cameras.

"A stylish new home community in South Granville that defines the fresh and intelligent architecture of Vancouver's future."

CAMERA

1523 West 8th, Intracorp

A convex sculpture the size of a city block that transforms light and movement into a difficult electronic matrix of sound.

"A sparkling gem with interiors as enlightened and smart as the architecture."

CROSSROADS

Cambie @ Broadway, Bob Rennie & Associates

DOMAIN

Main @ 12th, Holborn Developments

"The hippest condo, ever."

A glass cube, monumental in scale, that creates and displays its own weather patterns as generated by twelve iterative community built steam & wind mechanisms.

SAKURA

South Granville, Polygon Homes

"Custom designed vanities with imported solid marble countertops showcasing contemporary rectangular china washbasins."

A set of mobile sculptures shaped like tumbleweeds that are woven from historical video footage of blossoming cherry trees.

PURE

Drake @ Hornby, Bogner Development Group

"A fresh palette that will accommodate your tastes and furniture."

A carwash-sized robotic lung that uses infra-red laser to strip content from any media type, and outputs a shimmering black stripe of non-specific material.

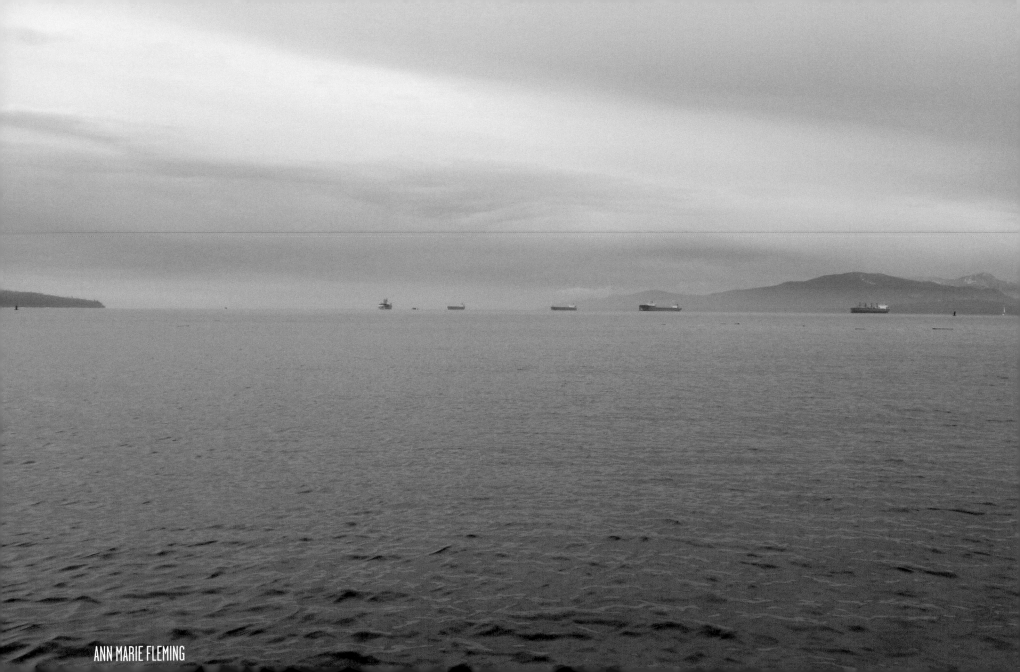

Salmon Recipes

1. salt crusted salmon
(this one is v. impressive. no one will ever forget this meal)
you need:
1 sockeye salmon, head on (you need the strong flavour),
a lot of kosher salt, many egg whites (8-10),
mint, aluminium foil, and a baking pan

preheat oven to 425 F.
mix the salt and egg whites together with a little water to make a meringue.
put down a bed of it on triple-folded aluminum foil, which is longer than the fish
by enough that you can curl up the edges, stuff the fish with mint. put it on the
meringue bed, cover with remaining meringue. cook for about 45 minutes.
put it on a slab of wood and smash it open at the table.
this fish tastes like it is still swimming.
serves 6 -20, depending on the fish. comments: "ooh!"

2. maple marinaded salmon
(this one is like candy!)
you need:
1 fillet coho salmon, garlic, tamari, olive oil, maple syrup

put the salmon in a plastic bag and pour in a little olive oil, a couple of cloves of
crushed garlic, a bit of tamari and a dribble of maple syrup. marinade. grill for
a couple of minutes a side. (or fry, or broil)
serves 2. comments: "wow!"

3. steamed salmon
(this one is delicate)
you need:
1 fillet white salmon (or another milder fish),
ginger, scallions, cilantro, soy sauce (optional),
sesame oil, vegetable oil, 2 woks with steamer ledge,
(or a large bamboo steamer)

put salmon on a plate. slice ginger and scallions very finely. sprinkle on a little
soy sauce, if desired. steam 5 minutes, or until flesh separates easily. heat a little
vegetable and sesame oil in a pan and pour over fish. scatter cilantro on top.
serves a few, depending on what else you put on the table.
comments: "mmmm.... i didn't know you could do this with salmon."

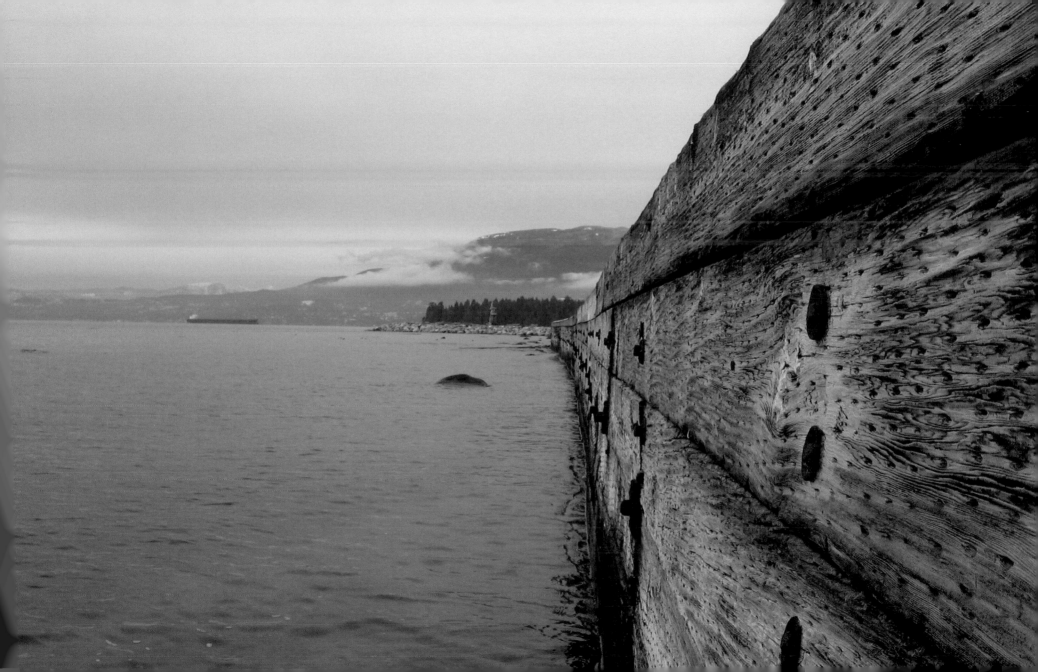

to be

sustaining
fundamentals

I had one of those dreams recently that you cannot forget in the daylight. More accurately I should call it a nightmare, but while living it there was no sense of horror or shock. I know this was a dream about the future of Vancouver as I was sitting in the living room of an apartment on about the fifteenth floor. We looked across to another glass tower and it was clear we were located on Main Street at about 18th Avenue and looking north. The topic of our discussion suddenly changed when out the window we saw a man step onto a balcony of this glass tower, climb up and dive to the ground some twenty floors below, ultimately becoming caught up in a tree. What was horrifying was not the dive, but that we immediately began giving him marks for aesthetics and technique, discussing his dive as if we were at the Summer Olympics. Soon we were comparing his dive to other examples we had seen recently, loudly debating if it was an "8" or a "6" because he had not managed to keep his form as he hit the tree. An ambulance noisily arrived to remove the body. One of my friends explained that the ambulances competed for these bodies as there was good money in such deaths. If survivors could not be located and charged, then apartment managers—or even developers—could be charged for renting or selling a tower apartment with a balcony to an unstable individual. Soon our conversation moved back to questions of film and film education as if nothing significant had just happened. The next day, still turning the dream over in my head, I first read the lyrics to Pearl Jam's "World Wide Suicide."

Pearl Jam's song is a critique of the War on Iraq, but it also captures the horror of our numbness towards the hell men have built on earth. In fact, this "world of pain" or "hell man-made" is nothing too new. I am old enough to recall when the War on Vietnam filled the daily news and if my parents picked up a hitchhiker they were likely to be a draft dodger. Despite the promotional claims to becoming a "world class city" with Expo 86, in many ways Vancouver remains as provincial and isolated as ever. Certainly the city has its horror stories, but what is new is the level of poverty and violence now accepted as the status quo on the Downtown Eastside. The DES, however, remains outside the average Vancouver imagination, except of course during civic elections when politicians of every creed feed off the tragedy and make empty promises about innovative change. The civic pride taken in the city's approach to addiction strikes me as consistent with a larger problem with the civic culture, namely, "world class provincialism."

KEN ANDERLINI

"World Class Provincialism"

I personally have no problem with provincialism. If I wanted to live in Toronto, I would move there. Provincialism can indeed mean recognition and acceptance of reality rather than striving to be something a city is not. Vancouver is not, nor can it ever be, London, New York City, or Shanghai. The problem begins when this ludicrous phrase "world class" becomes linked to provincialism. The result is the inane postmodern architecture that took root with Expo 86, transit systems designed for show and tell, and a civic culture organized around a desperate need to be seen at the circus. 2006 marked the twenty years since Vancouver claimed to be a "world class city," an anniversary marked by a wave of nostalgia for what local journalist Charles Campbell so eloquently has called "a new high water mark in bullshit." Expo 86 was for Campbell "an underachieving bore that gave us no clearly identifiable legacy that we couldn't have obtained without it." Campbell admits the fair may have helped improve cultural standards, and some local artists no doubt benefited from collaborations, but primarily "local cultural organizations simply tried to keep Expo from overwhelming them into bankruptcy." Rather than credit the fair for hatching a more cosmopolitan culture, Campbell suggests we take stock of the obvious—namely immigration, especially from Hong Kong—and the fact of being one of the fastest growing cities at the end of the century. Campbell also has some suggestions if the city truly does want to be "world class," including changing liquor laws for ourselves and not tourists, creating architecture worth mentioning, and recognizing and supporting "our own great new artistic talent with as much enthusiasm as we show for the rest of the world's has-beens."

The latest example of Vancouver's preening for international attention is the 2010 Winter Olympics, which a majority of Vancouver residents apparently approved of in a referendum. No such choice was offered other residents of British Columbia who will ultimately pay the debt for this white elephant, never be able to afford to attend, and never benefit in the way of employment. Cultural organizations short on cash were quickly recruited to jump on the Olympic bandwagon for what really amounts to spare change. Perhaps the most offensive aspect of the 2010 Olympics is that, as with Expo 86, it follows on a period of provincial cutbacks, showing that once again capitalist provincial governments can always find money for circuses even when they claim to no longer be able to afford bread.

One of the results of this "world class provincialism" is a city that makes the perfect backdrop for any Hollywood or television science fiction dystopia. Some Vancouverites have in fact come to take pride in the American film industry's use of Vancouver streets and cheaper labour. When the film industry is discussed in Vancouver it usually refers to American product, and not the work of Vancouver's own many talented filmmakers like Mina Shum or Bruce Sweeney. Vancouver visual artists have come to take note of the extent to which Vancouver has become a backlot, and have at times shown an intelligent ambivalence towards the endlessly blocked streets and parking lots filled with trailers. Yet for some unknown reason Vancouver curators often want to celebrate this colonial relationship, as if being Hollywood North was beneficial to Vancouver media artists. True enough, it does provide decent paying jobs for people out of film school—and Vancouver has many film schools—but I can think of very few colleagues for whom it provided an opportunity to move on to make their own work and not just pay off student loans. At best, it has allowed for the completion of the odd short 35mm film, produced from the ends of film stock that would otherwise have ended up in the garbage.

Whether it claims to be Hollywood North or a world class city, the tragedy of this myopia is that Vancouverites miss recognizing just how unique their city's culture has been, whether prior to or after Expo 86. The city can, in fact, lay claim to early contributions to environmentalism, including being home of the original Greenpeace, and the ethical scientist Dr. David Suzuki who gave up genetic research for broadcasting and teaching before founding the Suzuki Foundation. By the late '60s it was the home to an active hippy culture which transformed Gastown and Kits, and helped turn Wreck Beach into a famous nude oasis. In the '70s a highly political punk culture flourished. By the early '80s, a vibrant feminist culture had been established by way of media organizations like Women in Focus. As well, thanks to the work of the B.C. Civil Liberties Association, Vancouver has been at the forefront in defense of civil liberties and freedom of expression, most notably in the case of Little Sister's Book and Art Emporium. For a sleepy little town, Vancouver also has an admirable media art history, dating back to the Intermedia experiment of the late '60s that turned the Vancouver Art Gallery into a place of interdisciplinary research and set the stage for future artist-run media

organizations such as Video In Studios, the Western Front, and Cineworks. Thanks in part to conceptual artists like the Baxters of the N.E. Thing Company, even some New Yorkers in the late '60s visual arts scene recognized Vancouver as a happening place. The question remains, however, whether Vancouver residents recognize what they have or fail to see it because it does not look the same as what Los Angeles or New York have to offer. A telling example is the Vancouver International Film Festival that for years the mainstream press kept comparing to Toronto, bemoaning the lack of stars. It seems only very recently, with the festival now praised internationally, that it has become clear how comparing the two festivals does neither a favour.

Sustainability

Speaking to the Brisbane Social Forum, journalism professor and anti-war organizer Robert Jensen argued that the USA is in the grip of four fundamentalisms that threaten not only "sustainable democracy" but "sustainable life on the planet." He identifies these four fundamentalisms as religious, national, economic, and technological. While calling for the need of a separate analysis of each fundamentalism, he suggests that all share "a delusional overconfidence not only in one's beliefs but in the ability of humans to know much of anything definitively." Fundamentalism is "rooted in the mistaking of very limited knowledge for wisdom." The antidote he calls for is humility and "recognition of just how contingent our knowledge about the world is." Jensen challenges us to acknowledge our basic ignorance and adopt what sustainable agriculture researcher Wes Jackson has termed "an ignorance-based worldview." Jensen sees the humility of acting on not just what we know but what we do not know as underlying not only traditional or indigenous systems but also as a crucial lesson of the Enlightenment and science.

Canada is not of course in the same situation as our imperialist neighbour. While Christian fundamentalism has no doubt increased in influence, as seen by the minority success of the current Conservative party, and there are signs of both Jewish (Zionist) and Islamic fundamentalism, the nation remains a primarily secular and theoretically multicultural society. Our relationship to nationalism is also significantly different from our southern neighbour, and, in fact, nationalism may at times appear as a necessary solution to the threat of "deep integration" with the USA and the loss of control of our resources to the USA. With a Prime Minister eager to be recognized as George W. Bush's lap dog and a culture already monopolized by US corporations, we are in a situation where we should pay heed to our own interests while at the same time recognizing the historical dangers of nationalist myopia. Canada must also find a path towards a peaceful resolution of the nationalist aspirations of both Quebec and Aboriginal nations. A third fundamentalism, namely economic or market fundamentalism, quite clearly has taken control of our lives and culture perpetuating the myth that corporate capitalism is the only possibility and that a market propped up by government and monopolized by "multinational" corporations is free. As long as we remain trapped in this religious delusion, sustainability and democracy will remain unattainable. Finally, Canada is also threatened by technological fundamentalism, which Jensen clarifies as the belief that ever increasingly sophisticated technology is always beneficial and all problems it creates can be solved with yet more technology. The contributions made to global climate change by a transit system based on carbon dioxide emitting cars is the most obvious example today of the risks of not moving slowly in adopting new technologies, but the fossil fuel based "Green Revolution" which has destroyed our soil and the nutritional value of our food is another less recognized example. What the impact of GMOs will be is currently an experiment being carried out in North America largely without consumers recognizing it. The solution is not the complete rejection of technology, which is of course impossible, but rather a slowing down of adoption of new technology with consideration of consequences, as well as adoption of less spectacular technology such as indigenous and traditional solutions. The likelihood of this is, of course, slim, as long as economic and technological fundamentalism remains in control.

If the antidote to fundamentalism is humility, we might expect that art can play a role in teaching us to be human and live sustainable lifestyles. Not all art forms are necessarily equal in such a task of teaching us who we are rather than who we

imagine we want to be. Mainstream narrative cinema, for example, has clearly been part of the problem, and all the more problematic the closer it is to the corporate Hollywood model which itself is a spectacle engaged in national, economic, and technological fundamentalism.

Vancouver's celebration of the corporate industry is a perfect example of the mentality of world-class provincialism, but it is also vivid evidence of just how unsustainable our culture is. The resources which are put into a simple establishing shot of a character entering a building could well cover the costs of a student short, even if a stand-in was used instead of a star. There is nothing environmentally friendly about this waste and in the end it offers nothing to our culture but a continual dumbing-down as a consumer product replaces art and popular storytelling.

Despite the convention of the "Voice of God" and skepticism about its ability to represent an objective reality, documentary remains a mode capable of challenging fundamentalism at least to the extent it can remain free from the control of market demands, be they those of the box office or broadcasting. Self-reflexive and observational documentaries have long troubled fundamentalist truths, while activist work has shown how media production can be part of both identifying and analyzing issues as well as developing solutions. The line between documentary and experimental modes is never clearly fixed, and there is a long history at least as far back as Dziga Vertov of what can be called "experimental documentary." The promise of such work is not only in educating us as to how and why we are destroying the planet while providing grass roots solutions, but also in helping us think outside of fundamentalism. As such it can never be a cinema that uses a voice of God, but rather one that speaks with humility and to human frailty and failings.

The much larger field of experimental media art holds the greatest promise of challenging fundamentalism and promoting sustainability for the ironic reason that it is the most marginal of forms. Generally free from the demands of economic markets and associated aesthetic conventions, the experimental marks a wide terrain in which to

imagine a sustainable lifestyle and a viable future. As experimental media art is, at some level, an investigation of technique and technology, the experimental media artist cannot always avoid technological fundamentalism, particularly since the advent of digital technology. As the 1990s hype over all things interactive, digital, and virtual has been replaced by the banality of video gaming, blogging, and laptop presentations, the promises of the digital revolution have given way to seemingly endless upgrades and the cost of planned obsolescence. While format changes have always been part of media art and connected to its commercial basis, a well cared for Rolex might well have lasted the better part of a career. Computing systems are as stable as fashion or Top 40 music—the artist faces the possibility of making a final payment on a desktop editing system at about the same time as it becomes obsolete. Artists working in digital media who are concerned about sustainability face the challenge of carrying out a critique of the very medium they work in, a technology that is dependent on non-renewable resources and is a source of toxic waste even when recycled. Despite working with a technology that is not environmentally friendly and is driven by technological fundamentalism, the experimental digital media artist has a key lesson to teach, namely that "less is more." Experimental media has the potential to expand consciousness by showing us the extraordinary in the ordinary and doing so with the most minimal of resources.

If we were to create an avant-garde media culture that could play a role in building a sustainable lifestyle, a beginning would be in creating media arts clubs for youth. Such groups could work out of community centres, schools or even existing media arts centres and combine exhibition production and education. The goal would not be to train people for future employment but rather to teach people to create their own art and entertainment. As such we might want to call them slow entertainment groups, taking the term from the slow food movement. Creating their own films, video games, and other digital environments, youth could work the whole of corporate culture, and engage the ideas and values necessary for a sustainable and self-sufficient future. No longer consumers but rather producers of their own arts and entertainment, youth could break the whole of the corporate spectacle that consistently sells us sexual

frustration, speed, and violence. The Venezuelan Youth Orchestra might be a related model. In Venezuela almost every small town has its own orchestra and any youth who wants to can learn to play an instrument. This is an example of building community and self-worth. In Vancouver and the Fraser Valley every neighbourhood can have its own media arts laboratory addressing both local issues and larger questions of developing a sustainable culture.

For experimental media art to survive and play a role in shaping the culture and the future it must begin today by proving its relevance. We must resist the traps of producing decorative screens for galleries or eye candy for screening and rather take on the big issues and questions about the future of human culture and its survival—before we are driven to suicide or have become so culturally disabled we can no longer do anything. We must take on the task of building a sustainable culture. In the past, experimental media found new purpose and new audiences when it was picked up by artists with marginalized subjectivities; today our very survival is marginalized by corporate globalization and fundamentalism. Experimental media art has a role to play in helping us see the possibility of a sustainable future.

The Hollywood product has seen multiple challenges which have proposed a "reduce, reuse, recycle" ethic, famously in Italian neorealism, and cinema of minimal resources, but also in the Italian practice of reusing the sets left behind by Hollywood. Multiple realist cinemas have followed since and challenged First Cinema, including those developing digital cinema, from late '90s Dogme films to the indigenous productions of Igloolik Isuma. Bertholt Brecht and company had by the 1930s theorized and produced an "Epic theatre" which worked to deconstruct the theatrical spectacle and reveal the work of ideological production. While some attention has been paid to a Brechtian cinema, it remains undeveloped while Hollywood has proven adept at appropriating the look of the techniques aimed to undermine the status quo. Film studies have not necessarily helped, as attention has increasingly gone to reception and what use viewers make of films and television. Even left and feminist critics have become fascinated by populist readings of corporate culture, rather than launching challenges to the corporate capitalist product. This begs the question of the value in the real world of a reading which resists the dominant if in fact it has no actual impact on cultural production itself.

Experimental film and video has chosen alternative interpretations of the three Rs, appropriating the corporate product both from cinema and television to make the bits of visions often opposing the dominant lore. Guerilla media has come to signify a recycling of dominant images to force readings between the lines and make visible and audible the resistant readings transcribed in film studies. These techniques of recycling often run the risk of not only copyright infringement, but of maintaining the status quo as the sole frame of reference. Experimental media can risk reproducing dominant ideology and reinforcing that there are no other possible ways of being than those of corporate culture. While such critiques need to be risked, experimental media can move beyond to imagine another future and other possibilities. While the quick montage of media bites set to a rap tune is no doubt capable of a history lesson, it is insufficient in itself, for there are other ways of seeing and other worlds to see. A structuralist cinema, and even an amateur media, which hails back to video art's genesis in Fluxus and conceptual art presents the balance to media redux in finding its own minimal means to make us wonder and recreate the world. While the tension between the long take and the rapid montage need not exist in a single work, the contrast describes the potential of experimental media to not only critique the current insanity, but work to heal.

The waste and violence of lifestyle is unseen by an imagination addicted to corporate spectacle. Making visible the clear cuts, extinct species, contaminated rivers, and cancerous air between the cuts in the spectacle is the necessary basis of finding an ethical aesthetic and understanding beauty as the bringing together of means and ends. A community educated in an ethics of perception could break the addiction to the spectacle, challenging that media art need not contribute to the devastation.

Born September 11, 1962 in Langley, BC, Ken died peacefully at home on the family dairy farm in Aldergrove on April 16, 2007. From the beginning of his life, Ken's first love was to learn. He was a graduate of UBC with a BA in History. He completed a Masters degree in Film at SFU and taught in the Fine Arts Department there for many years. At the time of his death, Ken was in the last year of completing a PhD. in Art History at UBC.

Ken was a published author and well respected scholar who touched many lives teaching art history at Douglas College, Emily Carr, UVic and UBC as well as at SFU. For the past decade, he spent much of his Summers working for the Vancouver International Film Festival.

Ken was also a devoted fan of the Jersey cow and remained closely involved in the breeding of the registered cattle at his family's farm, Valtallina Jerseys. He had an extensive knowledge of the history of Jerseys in Canada and could recite a cow's pedigree for many generations.

Ken was a lover of all living things and remained deeply committed to human and animal rights throughout his life.

nobody?

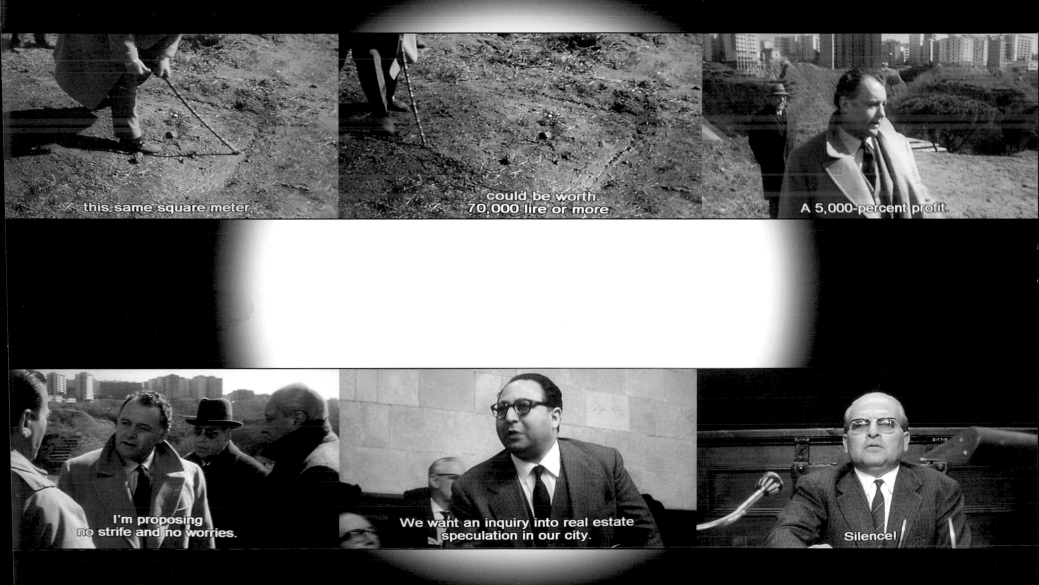

BARRY DOUPE

The big idea doesn't stand alone, but gets carved out of a collected series of events one on top of another.

...an A without a B, invisible vanishing points.

The beginning of the end was a move to a small house a block from East Hastings. It was on a corner where hookers not polished enough for the downtown strip would come and eventually disappear. From my small window upstairs I began to notice a pattern of decline where young women who seemed like high school girls would in the space of a month or two degenerate into raving scab-covered addicts. I would leave for work some days and there'd be a girl trying to restore herself with lipstick and powder in the side-view mirror of my car. There were awkward greetings but never names. Eventually they would not show up anymore and new faces would fill the void.

While living in this house, I found work on American feature films. Vast reservoirs of money pumped up from L.A. would send me along with legions of other technicians to spectacular locations all over the province. Sets that cost the production millions would be used for a week or two and then destroyed. If a director wanted to shoot where there was no access, a road would be built. If the terrain was too rough, helicopters were brought in. "We need a hundred more camels down there," was one of the more classic lines from a director looking down into the depths of the Fraser Canyon. It cost the production $100,000 in rescheduling, but a week later we were back down there with more beasts. The cash that hemorrhaged each day would have easily financed a dozen new media art projects or the operating costs of any number of rehabilitation programs.

The last one of these I would work on in Vancouver was Brian DePalma's *Mission to Mars,* a loose re-working of *2001: A Space Odyssey.* My boss came from an old film family in Hollywood and was not thrilled to be in Canada without his regular team. My first duty was to find painkillers for his aching back. His prescription for Vicodin was on its way but he could not function during the camera testing without chemical help. These drugs had a pronounced Jekyll and Hyde effect that turned my job into a psychological mine field. "Five hundred horsepower a piece" he would often gloat, about the photographs of his boat and truck that were tacked beside plans for his 2,000 square foot garage. My failure to genuflect and despondent attitude soon landed me over on '2nd unit' where our days were passed shooting to fill the gaps between close-ups of the actors talking. We shot computer screen displays, watch faces, stunt doubles being decapitated or launched. The production had constructed an indoor studio where the bulk of the 'acting' was done…a spaceship with massive rotating stages to simulate weightlessness…control rooms…green screens.

And then there was Mars.

A flat twenty-five acre section of Richmond covered by thousands of tons of lava rock coated by thousands of gallons of orange paint. We were a small army—300 people who would gather in the dawn's early light to order omelets with spinach and goat cheese, eggs benedict, smoked salmon, fruit salad, all washed down with lattes and cappuccinos. By mid-day, we might be onto our second or third set-up…garbage bins overflowing with styrofoam and plastic would be emptied while the throng lined up at the trough for another meal.

The glacial pace at which things happened gave everyone ample opportunity to consider their position in the universe. There were tremendous breaks…waiting for approvals on the angle of a miniature…a prosthetic head to be repaired…a crane to be positioned. Mercifully, being a member of the camera department meant that there was always something to take care of, order, check, test, clean, repeat. Most of the others fought the boredom as best they could…talking about the glory days of quadruple time and cocaine on *21 Jump Street*…playing backgammon and knitting… debating the evening's television offerings…new restaurants… property in Belize.

For months this went on…traveling to Mars for the day and returning to the grim spectacle that played out below my window at night.

A month before I walked away from that job, I met a very energetic young woman who was a sound assistant on the rare days when one of the principle actors would appear to re-shoot something that the director had not been happy with. Like myself, she was a member of the Cineworks independent film co-op, and was putting together a proposal for an "Omnibus" commissioned project. She was looking for filmmakers to add to her team and offered to include me on the application. The proposal was successful and I began shooting material for the film in earnest. The theme was something like "I, the city" which for me meant loading up my bike with a camera and reacting intuitively to whatever would happen on the ride. The first images were taken shortly after watching a seagull get hit by a transport truck along the waterfront. The bird bounced off the windscreen and managed to cartwheel through the air for another ten seconds before collapsing in the middle of the road. By the time I ditched my bicycle it had begun to hobble for the safety of the shoulder. This crippled walk and an extreme close-up profile of the gull's laboured breathing would become the core material of the film. After a few sessions on the optical printer and several bleary-eyed 4 am fumblings with an old cassette recorder to immortalize the ecstatic revelations of hysterical junkies below my bedroom window, I had a film titled *West Coast Reduction*—the name of a rendering facility a stone's throw from where I had encountered the bird. When the time came to prepare the original negatives to make a final print, I realized that several rolls were missing. I found one of them down at the lab and the producer, they informed me, had picked up the rest. A call revealed that her number was out of service. When I brought up the matter with the co-op, they told me that several of the other filmmakers were having difficulty getting in touch with her. By chance, I bumped into her brother who was in the process of cleaning out his desk, preparing to leave his job as the assistant equipment coordinator. He had not seen his sister recently but he did have a new number. Over the next two months I proceeded to leave a string of unreturned messages. In various measures I applied guilt, shame, compassion, reason, and reverse psychology until that number, too, went out of service. Her brother seemed pestered to hear my voice again, but when he found out that her number had been disconnected, his tone shifted.

A week later he left word on my machine to meet him at an address on 1st Avenue just down the hill from Commercial Drive. I will not soon forget the moments that followed shortly after he turned the key to unlock the door to his sister's apartment. It was an unusually hot day in Vancouver and I remember how the reeking wall of odour hit me as we crossed the threshold. On either side of the entranceway garbage was piled chest high forcing us to walk sideways to gain access to the main living room. At the end of this furrow lay a bare mattress floating on a sea of small tin foil squares. Giant blue bottle flies floated lazily in square orbits above as the sun melted in through the thick brown residue on the windows. The rest of the apartment was virtually inaccessible. Mounds of half-eaten take-out and empty packaged food containers had overtaken the kitchen. The shelves were overflowing with books and cans and boxes stuffed with crumpled paper…paper strewn everywhere…notes written in a furious hand…bits and springs from dismantled four-colour pens.

Her brother stood by the bed and told me the story. He had caught up with his sister as she was returning to the apartment one evening, and upon seeing her condition had put her on a flight to a rehab clinic in Newfoundland. He said that her decline had begun with a move-in with her boyfriend—a musician who had been struggling with drug addiction. He had abandoned the apartment with what was left of his equipment that same night. The two of us spent half an hour sifting through the shelves and boxes and collected anything that contained film material. As the smell in there conjured a raging headache, my spirits sank deeper, as none of the cans we turned up contained the footage. On the way out I noticed a white plastic grocery bag on a shelf that displayed the rounded form of a stack of film. The sac disintegrated like tissue paper as I lifted it from its perch, but inside were six loosely wound rolls. Back at my rewind bench with the stench of burnt carpet and rotting food colonizing my editing room, I had the missing negatives.

But the raft of dark visions that had plagued the film were not quite past.

The final episode was a noon-hour performance that took place below my window in a dented orange Toyota. I was logging the negative rolls for final printing when this car pulled up to the corner and parked with a jerk. A stringy-haired crack dealer in a leather baseball cap jumped out, slammed the door, and ran off across the street. The driver remained and I could see him trying frantically to find something in the glove box. A lighter…and then more searching…or was he starting to play with himself? What looked like a porno mag lay on the seat beside him now…and a spoon. He was wearing sweatpant cut-offs and lined up to poke himself in the thigh. Five minutes later with the needle still dangling from his leg a neighbour who was crossing the street startled him. The car stalled as he tried to get it into gear and then, flailing desperately with the stick shift, the car lurched forward onto the curb, narrowly missing a fire hydrant, and rounded the corner with tires squealing.

The stars were in perfect alignment now.

A call came in that afternoon from a very close friend who had been hired in Toronto to shoot a kids' show. He had no trouble convincing me that I should pack my bags and move east to pull focus for him. Driving over the prairies, it became clear that I had ended one of the darkest periods of my life with an exorcism…a film into which I poured all of the bad spirits, trapped them, and left them behind. I realized further that the entire body of work I had created while in that city was charged with sadness. I had been subconsciously overwhelmed by how the gross inhumanity I witnessed each night could exist alongside that gross wealth of Vancouver. It had crawled inside of me in this place where a film's importance is judged by the size of its budget...where "independent" meant drama under $10,000,000 and "experimental" was a vaguely remembered semester of boredom.

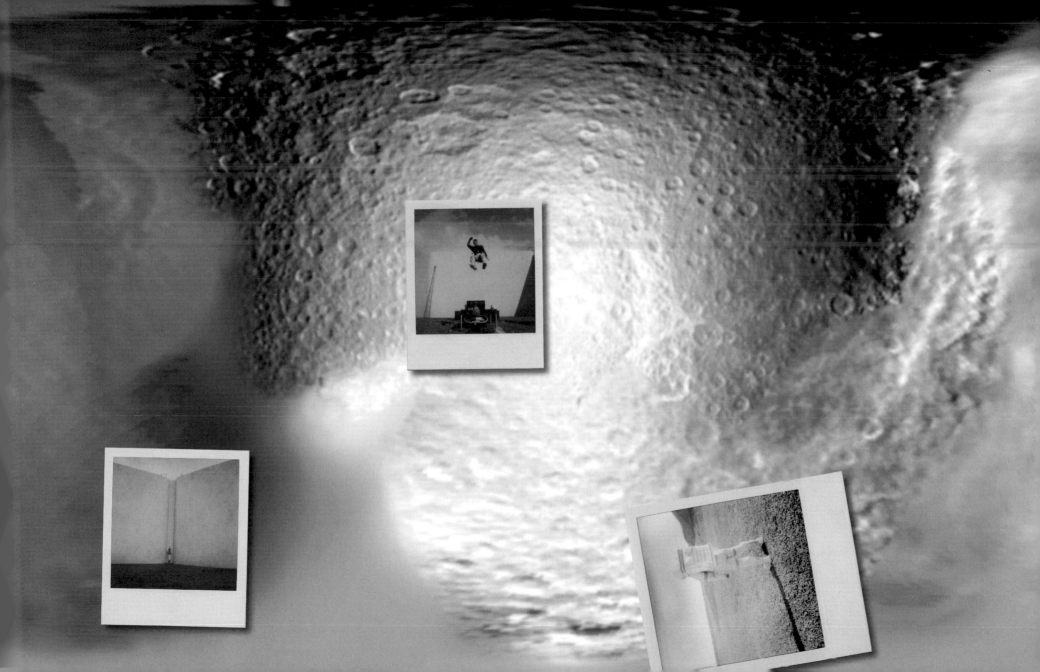

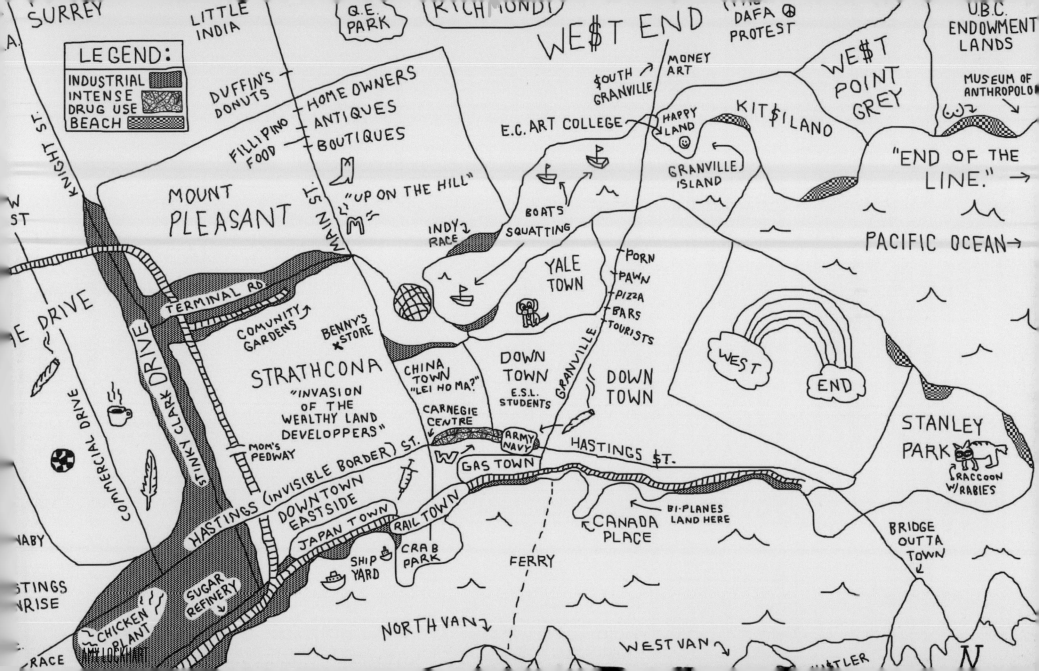

KEN ANDERLINI was completing his PhD in Art History in the Department of Art History, Visual Art, and Theory at UBC at the time of his death. He produced single channel films and videos and video installations. Unfinished works include *Wankers* (2000), an experimental documentary on gay cruising and the spaces of anonymous gay sex, (turned over to the collaborator for completion), *The Garden Project* (2007) based on photographic scans of a garden, and *I was wrong* (2007) a critique on his earlier work on HIV and AIDS. Ken's work is distributed by both Video Out and Moving Images.

WARREN ARCAND is a writer and multidisciplinary artist living in Vancouver.

KATE ARMSTRONG is an artist and writer with interest in networks, participatory systems, poetics, and hybridity. She has written for *P.S 1/MoMA*, *TrAce*, *Year Zero One*, *The Capilano Review*, and *The Thing*, among others. Her first book, *Crisis & Repetition: Essays on Art and Culture*, was published in 2002. Her artwork has been exhibited internationally.

FIONA BOWIE has exhibited both nationally and internationally—VandeVelde, Brussels; Consolidated Works, Seattle; Galerie Mladychu u Recickych, Prague; Presentation House, North Vancouver; Vancouver Art Gallery; and the Belkin Sattelite, Vancouver. Recent exhibitions include *Slip/host* at the Western Front, Vancouver (March 2007) and *Phenotypes*. Fiona is also producing a public arts commission for the City of Vancouver with Rebecca Belmore and Sidney Fels.

CLINT BURNHAM is a Vancouver writer and critic. His essays and reviews have appeared in *FUSE*, *C Magazine*, *fillip*, *Flash Art*, the *Vancouver Sun*, *doppelgangermagazine.com*, and in his blog at akimbo.biz. His books include the novel *Smoke Show* (Arsenal Pulp, 2005), and the poetry collection *Rental Van* (Anvil, 2007).

SARAH BUTTERFIELD is an experimental filmmaker, teacher and textile design artist. She has produced and co-edited a number of documentaries: *There is Plenty of Room* (1998) Betty Goodwin; *Krzyztof Wodiczko: Projections* (1991) Derek May; *Jack Wise: Language of the Brush* (1998) David Rimmer. Sarah is also a founding member and director of Champ Libre, a multi-media arts collective in Montreal which has produced four international digital media arts festivals.

JEFF CARTER has produced numerous films and videos, as well as providing technical services on a wide array of productions. His projects include "Conceptual Vancouver" films such as the *Great Leap Forward* series (1994-present), media deconstructions such as *Iraq War(s)* (2004), music projects such as *Powerclown: Maiden East Van* (2002), and temporal mood films such as *Inside Passage* (2007).

AMANDA DAWN CHRISTIE is an interdisciplinary artist (film, contemporary dance, photography, textiles, and electro-acoustic sound design). Her current work revolves around hand-processing and optical printing, and her films explore issues of memory and sensuous geographies as they relate to the identity politics of region and religion.

PETER COURTEMANCHE is a contemporary sound and installation artist from Vancouver. He is the former Director and Curator of the Western Front's Media Arts Program and has worked extensively in radio-art, electronic/interactive interventions, and networks.

RANDY LEE CUTLER is an educator, artist and writer investigating the intersections of embodiment, art, theory and technology. Her practice lies in the exploration of alternative possibilities for being in and interpreting the world. She is Associate Dean, Integrated Studies at Emily Carr Institute, Vancouver.

BARRY DOUPE holds a Bachelor of Media Arts degree from Emily Carr Institute of Art & Design. He is also a member of The Lions collaborative drawing group. His films have been screened throughout Canada and internationally, including the Ann Arbor Film Festival, Anthology Film Archives, Lyon Contemporary Art Museum, Pleasure Dome, and the Tate Modern.

COOPER BATTERSBY and EMILY VEY DUKE have been working collaboratively since June 1994. Their work has been broadcast and exhibited around the world. Duke and Battersby are currently teaching at Syracuse University in Central New York. They are represented by Jessica Bradley Art and Projects in Toronto.

ANN MARIE FLEMING is one of Canada's most distinctive independent filmmaking talents. She has created a remarkably diverse body of work, including feature, short, documentary, avant-garde, animated, and personal work with over twenty films in her oeuvre.

DAVID CROMPTON and ANDREW HERFST formed a multidisciplinary art practice in 2000 based in Vancouver. Their collaboration aspires, in part, to explore specific relationships; the aural and the visual; the landscape and the portrait. Their work, unhurried and deliberate, is marked by the passage of time. Carefully structured compositions are intertwined with autobiographical details, resulting in work which is both formal and lyrical.

OLIVER HOCKENHULL works in film, video, hypermedia, writing, design, documentary and philosophy. He has exhibited his work at screenings, festivals, and broadcasts worldwide. His most recent post was as a visiting artist at Northwestern University, Chicago. Most recent screenings were at the Festival du Nouveau Cinema, Montreal and at Economie o, Paris. He has completed six feature length works and numerous dramatic and experimental shorts and is currently working on an experimental film on energy, flow, and power exploitation in British Columbia.

YUNLAM LI is a media artist living and working in Vancouver.

MICHAEL LITHGOW is completing an MA in Media Studies at Concordia University in Montreal. Previously, he spent a number of years as a community television activist, organizer, and producer in Vancouver. He has also been active in community radio and video art as a producer and curator. He is currently the new media editor for *Art Threat Magazine* (www.artthreat.net).

AMY LOCKHART's short films and artwork have been exhibited extensively throughout North America and beyond. She has completed residencies at the Quickdraw Animation Society and the California Institute of the Arts, and was awarded an animation fellowship with the National Film Board of Canada. Her work was shown in Bit by Bit at the Contemporary Art Gallery in Vancouver and her work appears in *Nog A Dod*, an anthology of Canadian psychedelic art published by Conundrum Press.

LAIWAN is a recognized interdisciplinarian with interests in poetics and philosophy. Born in Zimbabwe of Chinese parents, she immigrated to Canada in 1977 to escape the war in Rhodesia. She teaches at Goddard College in the MFA in Interdisciplinary Arts, Vermont.

PIA MASSIE is a multi-media artist whose film and installation work has been exhibited in festivals, museums and galleries throughout North America and Europe, including The MOMA, NYC; Musee Cantonal des Beaux Arts, Lausanne; the List Center for the Visual Arts, Massachusetts and the grunt gallery in Vancouver.

ALEX MACKENZIE works with light projection and expanded cinema. He was the founder and curator of The Edison Electric Gallery of Moving Images, The Blinding Light!! Cinema and the Vancouver Underground Film Festival. His live media works are presented at festivals and underground screening spaces throughout Europe and North America, most recently at the Rotterdam International Film Festival and the K-raa-k Festival in Brussels. He is currently designing handmade film emulsions and manually-powered projection devices for installation and live performance.

NORMA is a collective of eight young artists of diverse backgrounds, most of whom live and work in Vancouver, B.C. During the last four years, Norma has produced installation and performance works that employ absurdity, physical endurance and repetition in an exploration of collective identity and cultural anxiety.

ILEANA PIETROBRUNO is a hands-on filmmaker who writes, directs, produces, edits and art-designs her own work. She has made several short films and two features: the darkly surreal *Cat Swallows Parakeet and Speaks!*, and the raucous, gender-bending *Girl King*. Her films have won awards and screened at hundreds of film festivals, including the Berlin International Film Festival & the Toronto International Film Festival. Ileana is currently working on *Nana_350*.

JOHN PRICE has produced experimental documentaries, dance and diary films since 1986. His love of photography has led to extensive alchemical experimentation with a wide range of motion picture film emulsions and formats. His work has been exhibited at festivals and galleries internationally. He has also produced film projections for opera and dance and currently teaches cinematography in Toronto.

DAVID RIMMER's distinctive and emotionally resonant body of work is at once subtle, structurally meticulous, and profoundly moving. Truly a local living legend, he remains one of Canada's foremost experimental filmmakers.

JAYCE SALLOUM's work exists within and between the very personal, quotidian, local and the trans-national. His work engages in an intimate subjectivity and a discursive challenge. He has worked in installation, photography, video, performance and text since 1975, as well as curating exhibitions, conducting workshops, organizing collectives, and coordinating sustainable cultural projects.

CHRIS WELSBY has been making films and film/video installations since 1969. Exhibitions include the Tate Gallery, Musée du Louvre and Museum of Modern Art. A co-founder of the (New) Media Department, Slade School of Fine Art, London University, he is currently a professor of fine arts at Simon Fraser University, Vancouver.

T'UTY'TANAT-CEASE WYSS is from the Squamish village of Ela7an, located in North Vancouver, B.C. Cease has been creating Media Art for close to fifteen years, and has dedicated many years to Outreach Training with communities throughout B.C. She currently resides in the village of Sunaq', with her daughter Senaqwila, who is an art student attending Nootka Elementary School.

CONTRIBUTORS

All layout/design by ALEX MACKENZIE and OLIVER HOCKENHULL unless otherwise indicated.

KEN ANDERLINI
Colour photo found (online, uncredited). Black and white photographs courtesy, City of Vancouver Archives: Air P106.6, Van Sc P7, Air P24, CVA 677-712.

WARREN ARCAND
Photographs and Device by Warren Arcand, photos of Device by Oliver Hockenhull.

FIONA BOWIE
Stills by artist.

CLINT BURNHAM
Image by author.

SARAH BUTTERFIELD
Backgrounds by artist.

JEFF CARTER
Photographs by Alex MacKenzie.

AMANDA DAWN CHRISTIE
Illustrations by artist; images from Oxberry Instruction Manual; photographs by Alex MacKenzie.

RANDY LEE CUTLER
p.19: *untitled (20 Street lights & grass): 55 seconds* by Lawrence Sims, (inset) *...Um* by Hadley + Maxwell (2006); p.20: Neil Campbell, *Base (Machine)* (2005), Lightbulb Schematic, United States Patent Office; p.21: *untitled (23 overpass): 70 seconds* by Lawrence Sims; p.22: Neil Campbell, *Base (Machine)*

(2005); p.22/23: *untitled (4 parkade booth): 45 seconds* by Lawrence Sims; p.23: *untitled (21 pile of concrete): 160 seconds* by Lawrence Sims; p.24: *Interior at Hycroft Mansion* Courtesy City of Vancouver Archives, CVA 434-5.

BARRY DOUPE
Illustrations: *Girldogboobs* and *Cyclops* illustrations by The Lions Collective; video stills from *Distraught Mother Reunites With Her Children* (2005) and *At The Heart of a Sparrow* (2006) by the artist.

COOPER BATTERSBY & EMILY VEY DUKE
Paintings by the artists; rant page text by the artists, design by Oliver Hockenhull.

ANN MARIE FLEMING
Photographs by the artist; fish Illustration found.

DAVID CROMPTON & ANDREW HERFST
Images and design by the artists.

OLIVER HOCKENHULL
Images by the artist except "Pachinko", used with the permission of Professor Akiyoshi Kitaoka. See his online pages @ http://www.ritsumei.ac.jp/~akitaoka/; bird page photos & design.

BRIAN JOHNSON
Stills from his film *Soft Revolution* (2007).

YUNLAM LI
Photographs from a series entitled *The Museum of Modern Ruins: Ocean Falls*

AMY LOCKHART
Illustration by the artist; facing photo by Alex MacKenzie.

LAIWAN
Micrograph image © Charles Sanders/BPS

PIA MASSIE
Photographs by the artist.

ALEX MACKENZIE
Filmstrip reproductions from *The Wooden Lightbox: A Secret Art of Seeing*; design by Alex Mackenzie.

NORMA (COLLECTIVE)
Photographs and photomanipulation by the artists.

ILEANA PIETROBRUNO
Black & white still by Athena Wong; colour stills by John Houtman.

JOHN PRICE
Polaroids by the artist; space imagery, courtesy NASA.

DAVID RIMMER
Stills from his film *An Eye for an Eye (2003)*.

CHRIS WELSBY
Stills from his film *Skylight* (1988).

Francisco Rosi stills from *Hands Over the City*, courtesy of Janus Films.

Al Fallujah and Vancouver Satellite photos, courtesy NASA.

IMAGE/DESIGN CREDITS

landscape of unbearable and limiting entrapment sits sidelong with a soft and supportive cradling to create the central dichotomy to be found in this geography: the seductive and dreamy indolence of the lotus-eaters sleeping, and the inevitable revealed as a ruse, a reductionist approach to a life philosophy and a narcissistic indulgence that fuels the fires of our heroin culture, harm reduction and self-satisfaction. How does geography, architecture, and landscape affect and impact conflicts between nature and culture, the public and the private be resolved, and how to explore this proscenium? Neoteny Encourages Autonomy 1. neoteny (adj. neotenous) The retention of juvenile characteristics in the adult individual. neoteny Canadian La-La land of perpetual youth and utopian aspirations, has yet to establish a mature media scene. All is haphazard and dependent, with the occasional individual or gallery rising above the current of the "new to be of note"—to dissipated. The neoteristic retains a playful relationship with the key terms of the 'adult' world, becoming the most essential, radical (root) reader and critic of the ossified social and aesthetic. The playful is the creative—it is the juvenile flexe transgress the status quo? Life in a rainforest stinks of earth, water, rotting wood and chlorophyll—new plants rise from composted stumps—skunk cabbages and hallucinatory mushrooms proliferate, life breeds on death, and the cycle is both most oppositional to mainstream culture—that a distinction can be delineated and rendered perceptible. Unfortunately in this era of flattening and standardization (from the mainstream to the global art world), this kind of uniqueness is simply counted, and only that which is needed. By its very nature the avant-garde media positions itself outside of the institution, the gallery, and the consumable object (read: high and commercial art). Given its temporal form, its inability to be saddle with hope and hopelessness: in a single moment, a guarantee of a reaffirmation of meaning. A Pacific Futurism in this City of Rain reflects a shiny and brutal presence, calls forth the capacity of only an imagined technology. It is the end

ad-end. James Hilton's valley of Shangri-la was a peaceful place, taking from the world around it while remaining aloof from all the negative actions of that world. Following, and upon close examination, the idea of a New Age philosoph

ities and pursuits of the media artist? What does their work bear in responsibility and offer in response? Where does the individual artist sit in relation to this paradigm of landscape, of spiritual journey—and where does it lead? Can the confu

rolongation of a period of immaturity; retention of infantile or juvenile characteristics into adulthood. neotenous, adj. neoteric adj.—new; modern; n. such thing. neoterism, n. neologism. neoterist, n. neoteristic, adj. neoterize, Vancouver, the Canada

e in the wash of tomorrow. As a remote city in the landscape of Canada, Vancouver is a city of immaturity: financially, conceptually, and artistically. When logical typing is seen to be a function of convention, institutional authority is dissipra

ons via answers that are surprising for their lack of maturity (the foregone conclusion of the status quo). How can ideas of reprocessing, reinventing, and reifying lead us to a new understanding of the ongoing potential of media art to transgr

This rapidity encourages a heightened mutational rate. The complexity and uniqueness of the environment of the West Coast once fostered a very specific culture. Now it is principally in the avant-garde—that area of cultural production (m

ommodified—sold back to the citizens, while complexity is reduced, denied, and colonized. How to refuse this coercion? Hearing and seeing only what they want—they hear and see only their want. The avant-garde gives only that which is

bject fetish potential, and its constant desire to reinvent itself, the moment the lights come up again—it is a living potential never to be fulfilled. When successful, this utopianistic gesture, often and contradictorily rife with distopian visions, is

st, or, less dramatically, a dissolving of the West, into the intricacies of the circular world. Can this infinite potency be resolved, and should we even seek this resolution? We entertain the future of the form in Vancouver as well as its futurist cons